LEARNING BY DOING

Northwest Coast
Native Indian Art

RAVEN PUBLISHING
P.O. Box 325
5581 Horne Rd.
Union Bay, B.C. V0R 3B0
Phone: (250) 335-1708
Fax: (250) 335-1710
email: artandculture@ravenpublishing.com
website: www.ravenpublishing.com

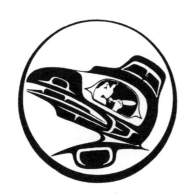

6th printing, 2001.

Distributed to the book trade by:
Northwest Coast Indian Books
P.O. Box 670/720 Hwy 33
Queen Charlotte City, B.C., Canada, V0T 1S0
Phone: (250) 559-4681 Fax: (250) 559-8643
email: nwcbooks@island.net
website: www.abebooks.com/home/indianbooks

ISBN-0-9692979-1-2

TABLE OF CONTENTS

FORWARD

Northwest Coast Native Indian Art is enjoying a well deserved growth of interest worldwide. This includes Native artists themselves, art collectors, cultural researchers, artists who wish to incorporate Native design, children and adults in the school system, seniors, and craftspeople in many industries.

In order to analyze form, style and substance, it is necessary to have a base or tradition from which to spring. Bill Holm's *Analysis of Form*, or Hilary Stewart's *Looking At Northwest Coast Indian Art* filled a gap for the general public that Native Artists who were laboring to restore the art via apprenticeships and small local classes were unable to fill.

We designed Northwest Coast Native Indian art to more fully explore one art style. We found that the best way to really learn about the art was to attempt to do it. The understanding of not only style and form, but also cultural pride and heritage achieved by the children and young adults who have used this approach in the school system is very impressive.

The concepts in the book are arranged from simple to complex with each sequential step building on each previous step. The elements of Northwest Coast Native Indian art have been analyzed as to form, line, colour and characteristics. Certain universal skills such as drawing, painting, and carving are taught in traditional ways as well as modern.

Individual learning styles, learning rates, and interests of readers have been accommodated within the lessons. Created because of the popularity of Northwest Coast Native art, the book touches on Nuu Chah Nulth (Nootka) and Salish art as well as Kwagiulth (Kwakiutl). There are also similarities to the art of the Natives of the entire Northwest Coast from Alaska to Northern California. It can therefore be modified so that it is specific to the area in which it might be used.

Fifteen concepts are presented; the first six are single elements of the art such as ovoids, split 'u's and their variations and the next nine concepts combine the first five elements so that the elements begin to have meaning. Each single element is also pictured as part of a whole design at each stage, so that the learner has a global as well as analytical look. They represent, in the abstract, the animals and spirits in nature. The learned abstract forms of art can then be used to interpret any story or legend.

Perhaps one of the greatest benefits of learning by doing, an understanding of both oneself and the complexities of a special culture results from having completed these lessons. Critical appreciation and analysis of any other similar art form is possible, to a greater degree. We found that we passed from the stumbling, painful steps of the beginner to the satisfaction and reward of having given this new, and unusual art form our best try.

We hope that you, too, will find a similar satisfaction.

Karin Clark & Jim Gilbert

CONCEPTS

SKILLS	Concept #1 Basic Ovoid	Concept #2 Basic Ovoid with Eyelid Line	Concept #3 'U' Shape	Concept #4 Split 'U' Shape	Concept #5 Reverse Split 'U' Shape
Drawing	*	*	*	*	*
Painting Techniques					*
Painting on Paper					*
Painting on Wood					
Transferring to Paper					
Transferring to Wood					
Preparing Wood for Transfer					
Using Knives/Sculpted Forms					
Carving — Bas-Relief					
Carving — Interior Areas					
Carving — Total Form					

CONCEPTS / SKILLS	Concept #6 Variations in 'U' Shapes	Concept #7 'S' Shape Box End Design	Concept #8 Salmon-Trout Head	Concept #9 Killer Whale Head	Concept #10 Eagle Head
Drawing	*	*	*	*	*
Painting Techniques	*	*	*	*	*
Painting on Paper	*	*			
Painting on Wood			*	*	*
Transferring to Paper	*	*			
Transferring to Wood					
Preparing Wood for Transfer					
Using Knives/Sculpted Forms					
Carving — Bas-Relief					
Carving — Interior Areas					
Carving — Total Form					

SKILLS \ CONCEPTS	Concept #11 Knife Handles	Concept #12 Bas-Relief Whale Head	Concept #13 Bas-Relief Eagle Head	Concept #14 Carved Serving Tray	Concept #15 Ceremonial Paddle
Drawing					
Painting Techniques					
Painting on Paper					
Painting on Wood					
Transferring to Paper					
Transferring to Wood					
Preparing Wood for Transfer					
Using Knives/Sculpted Forms	*	*	*	*	*
Carving — Bas-Relief		*	*		
Carving — Interior Areas			*		
Carving — Total Form				*	*

CHAPTER ONE

INTRODUCTION AND THEORETICAL CONSTRUCT

CHAPTER ONE

INTRODUCTION AND THEORETICAL CONSTRUCT

Many experiences contribute to the concept called "knowing". As a child travels through life, she begins to construct meaning through her interpretations of her experiences. In former times much of this construction of meaning came about through observation and participation in the events of daily life. Bruner states:

> "The child first learns the rudiments of achieving his intentions and reaching his goals. En route he acquires and stores information relevant to his purposes. In time there is a puzzling process by which such purposefully organized knowledge is converted into a more generalized form so that it can be used for many ends. It then becomes "knowledge" in the general sense — transcending functional fixedness and egocentric limitations."
> (Bruner, 1971, p. xii)

People had well-defined roles and acquired the skills necessary to them in their roles by imitating models.

Our present way of life requires not only the negotiation of various life stages but also culturally acquired knowledge far beyond what one or two individuals might be able to impart. There is no longer time for knowledge to be slowly acquired through absorption and participation in daily life activities. "Knowing" still proceeds in the same way as always but now there is so much to choose from that choices must be narrowed and acquisition of knowledge guided through a curriculum.

Instructional Techniques

1. Make material meaningful
2. Use small sequential steps
3. Provide distributed practice
4. Provide overlearning
5. Teach in several contexts
6. Consequate correct responses (reinforcement, corrective feedback)
7. Elicit the correct response (cueing, properly phrased questions, directing attention)
 (Salvia, 1982)

Some theorists supporting these techniques are Ausubel, Ellis, Spitz, Skinner, Zeaman and House.

The word "curriculum" comes from the Latin, meaning a "race" or a "course". Bruner states that a curriculum is the

> ". . . conversion of learning into a form comprehensible and nutritious to the young."
> (Bruner, 1971, p. 18)

The United Indians of All Tribes Foundation likens curriculum to "a road by which a learner gets from one place to another place. It is a road for movement and growth." ". . . it assists people to attain, to the best of their abilities, the knowledge, values, and skills held most important by the Native community." The ways of a society are thus passed to the next generation which then builds and modifies learned concepts.

In order to focus on the most important bits of information available within the incredible amount of information that is continually being generated by myriad researchers, a theory is necessary to get rid of the clutter. Bruner states that:

> "a concept or the connected body of concepts that is a theory is man's only means of getting a lot into the narrow compass of his attention all at a time."
> (Bruner, 1971, p. 119)

While searching for a theory that adequately frames learning, it is important to think of both developmental psychology as well as pedagogy. When discussing education innovations of the 70's, Bruner says:

> ". . . developmental psychology without a theory of pedagogy was as empty an enterprise as a theory of pedagogy that ignored the nature of growth."
> (Bruner, 1971, p. xiv)

In order to develop a curriculum that is sound, it is important to keep in mind the concept of universality (Piaget's stages) as well as the concept of cultural diversity. The second concept includes an appreciation of human culture, which revolves around a reciprocal exchange through symbolic, affiliative and economic systems. The first concept includes universals such as curiosity, play, planfulness, anticipation, leading ways of seeking, transforming, representing, and using information.

A hierarchy of "knowing" can be shown through Bruner's stages. One first experiences through action, them imagery, then, lastly, through symbols. A way of cultivating the thinking, problem-solving capacities within a person is through art. Webster defines art as "the disposition or modification of things by human skill, to answer the purpose intended. In this sense "art" stands opposed to "nature"." Using Bruner's sequence, learning may begin with an inactive representation such as learning art by drawing and designing with a highly simplified form analysis.

To the Native Indians of the Northwest Coast, art, and myth became the highest symbolic embodiment of knowledge. With their high technical skills they modified nature so that it graphically made visible concepts as complex as any in our printed language. Forms, though based on realistic nature, were highly abstract and transmitted religious and social knowledge from generation to generation. Art, dance, song, myth, legend and ritual were the means of cultural transmission and psychological development.

Cultures of today still use art as a graphic representation of knowledge. It is, however, more personal. It not only shows one individual's view of a part of his world, but also it contains the feelings of the artist. Pride, hope, pain, ecstasy, despair are all transmitted without benefit of words. The resurgence of these feelings in the Native Indian community makes necessary an outlet of expression. Expression through the traditional Northwest Coast artform gives native people of this coast a completely unique approach. Nowhere on earth is there an art form like it. Not only is it unique, but it is highly technical and sophisticated. Once learned, expression through this form should generate a sense of autonomy and competence in the broadest personal sense.

Not only Native Indian children would benefit from learning to use the art of the Northwest Coast. In the same way that learning a language allows a speaker to live and "know" in a different culture, art also transmits the knowledge and feelings of a culture. Respect for and an awareness of cultural differences results. The old proverb, "To know a man, walk a mile in his shoes", was based on a basic truth. One must experience in order to know. In an article written for the book, *Arts of the Raven*, master Haida artist Bill Reid states:

"Whether my impressions are true or not, these vanished men and women have emerged through their art out of a formless mass of ancestral and historical stereotypes — warriors, hunters, fishermen, every man his own Leonardo — to become individuals in a highly individual society, differing in every detail of life and custom from us, but in their conflicts and affirmations, triumphs and frustrations, an understandable part of universal mankind. So the art, because it embodied the deepest expression of this essential humanity, can be as meaningful and moving to us as it was to them . . . They told the people of the completeness of their culture, the continuing lineages of the great families, their closeness of the magic world of universal myth and legend."
(Reid, 1974, p. 43)

Justification and Need

The demand by Native Indian people to know more about their culture put great pressure on those few individuals left who had preserved their culture's skills and traditions. More young people became apprenticed to master artists (as well as dancers, crafts, and other skills) and started to create fine traditional work. The art world became interested in this Native work as art rather than ethnography. Increasing interest on the part of Native people, the art world and other cultures stretched the resources of skilled artisans.

Once again, increasing knowledge and demand changed the way skills could be transmitted. An established way of facilitating learning, the curriculum, was needed. The Victoria School District, under its Native Indian Education Division, established priorities based on needs and wants within the Native Indian community. One of the priorities was art education. Great numbers of native and non-native students were enthusiastic about art courses offered at the Junior, Senior and Elementary levels of the public school system. The pupil-teacher ratio (master-apprentice) changed from one to one, two or three, to one to thirty. A sequential, skills-based curriculum was begun on a trial and error basis.

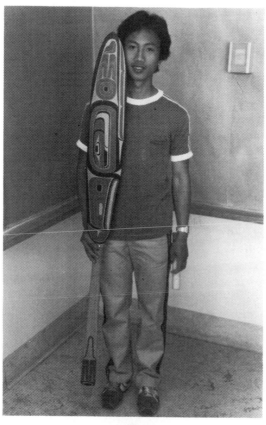

CHAPTER TWO

REVIEW OF THE LITERATURE

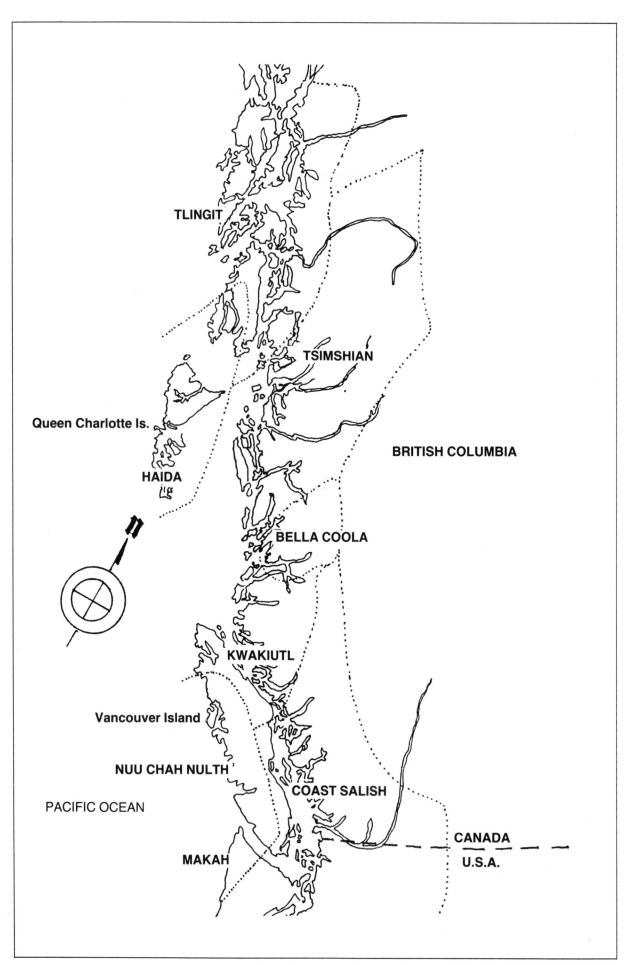

TLINGIT

TSIMSHIAN

Queen Charlotte Is.

BRITISH COLUMBIA

HAIDA

BELLA COOLA

KWAKIUTL

Vancouver Island

NUU CHAH NULTH

COAST SALISH

PACIFIC OCEAN

CANADA

U.S.A.

MAKAH

NORTHWEST COAST NATIVE INDIAN
CULTURAL BACKGROUND INFORMATION

CONTEXTS OF NORTHWEST COAST NATIVE INDIAN ART

The People

Northwest Coast Native people lived in fairly large villages with permanent plank housing. They used canoes to hunt, fish, trade, visit and make war. Since food gathering did not take all their time, they were able to develop a fine woodworking technology. Their elaborate sculpture and graphic arts were the "written" record and the visual transmitter of social and religious meaning. Today, there is renewed enthusiasm among Native people toward some of the customs and rituals that give meaning to their culture throughout time. Dances, potlatches, name-giving ceremonies — all are bound inextricably to the art.

This curriculum touches mostly on the northern third of Vancouver Island where people spoke dialects of the Kwakwala language. There is a distinction in art styles between the Kitimat and Bella Bella people, and the southern Kwagiulth *(Kwakiutl) of Vancouver Island and the mainland opposite. The northern groups shared the same general art styles as their northern neighbours (Haida, Tlingit). The southern groups have a related style and it is on this style that the curriculum is based.

The Time

The time of European contact saw increased artistic production. New wealth expanded the scope and variation of social and religious traditions. There was a greater need for crest and spirit representations. Totems became larger and more varied in type. New tools and new materials were being imported by traders who saw a new market in Native "curios" to museums and collectors. Whole new industries like argillite carving, model-making and silver jewellry engraving were created. The peak of this production, in the latter 19th century was represented by master artist, Charles Edenshaw. He carved first masks, totems and other necessities of a living Haida culture then turned his skills to saleable, tradeable items like argillite and silver.

The Sculpture

Craftsmanship rather than artistry appears to be the basis of the art. Objects representative of a living culture, such as: totem poles and canoes, partition screens and chief's seats, feast dishes and ladles, masks and other stagecraft devices, crest helmets and speaker's staffs, carved cradles, combs, and fishhooks — all came from the hands of woodworkers. Sculpture in other media was created by transferring woodworking concepts. Small dishes, ladles, and spoon handles were carved from horn. Tiny shaman's charms and soul catchers were created from bone, antler and ivory. A few items — tobacco mortars, paint dishes and some figures and clubs were carved from stone.

The Painting

At first, flat wooden surfaces such as boxes, chests, partitions, screens, and house fronts were painted. Later, flat skin garments, paddles, canoes, hats and baskets were also painted. Similar designs could then be made by other methods such as negative carving on wood, engraving on metal, weaving or appliqué on textiles. This combination of sculptor's and painter's skills was to be seen in all aspects of the culture. People lived in an environment created by artists.

*Kwagiulth (Kwah-gew't) — Southern Kwakiutl people of Fort Rupert, Vancouver Island.
Kwakwala — Language spoken by 'Kwakiutl' people.

The Meanings

Northwest Coast art is abstract, representational art. There was heavy emphasis on faces and heads. Masks, rattles, headdresses, staffs, totem poles and other forms give faces emphasis in style and form. They could take the form of serene or savage creatures. They could be humans, spirits, animals or supernatural creatures. Sometimes the artist put faces where none exist in nature: in body spaces, in ovoid joints, at the base of limbs or tail, or anywhere a suitable space remained unfilled. The subject of the painting also had to be adapted to the size and shape of the object it was to decorate. Animal and human designs represented either crests or spirits.

The Spirits

One purpose of the art was to make the supernatural world visible and present. A shaman's charm identified a spirit helper through whom he received his power.

The Crests

Another purpose of art was to make the social system visible. Emblems were used to distinguish different social groups and to symbolize their history and privileges. They could be shown on many material possessions, from robe to totem pole. Emblems contained no power; they hold social significance rather than religious.

The northern tribes had clear-cut social groups based on kinship traced through the maternal line and each owned the right to display specific crests. Within each group, families or individual chiefs owned different crests or had the right to show the general crests in specific ways. Art provided the highly visible status symbols of the social system.

The Styles

The styles of art could be individual and/or regional. Of the regional styles, two are of particular note regarding this curriculum: (1) Northern (Haida and neighbours), (2) Southern Kwagiulth (Kwakiutl). One theory states that the two styles might be described as blends of two artistic traditions: an underlying sculptural tradition (Old Wakashan), and a superimposed surface tradition (Northern Graphic).

Kwagiulth style developed after contact and is still evolving. The sculptural freedom of Old Wakashan is retained but it is covered by a veneer of surface decoration which has elements drawn from the Northern Graphic tradition.

Philip Drucker states in his book that the Old Wakashan tradition is seen in its purest form on the wood carvings of the Kwagiulth and Nootka from earliest contact. It was not concerned with surfaces; large areas were left plain so that the eye could move to significant sculptural details. If paint were applied at all, it was used to emphasize sculpted forms not to add decoration to the surface.

The Northern Graphic style consists basically of two dimensional designs applied to surfaces. It was a painter's tradition. The subjects were mainly human and animal; specifically, they were crests. Clear conventions regarding abstract representations and full face or full profile were observed. Artists distorted nature by reducing a subject to its essential parts, exaggerating, distorting or dislocating and rearranging these parts within the design. Symmetry was the dominating principal. It would "split" a subject into two symmetrical parts. Profile views extended for all or part of the length. Certain features were accentuated to aid in identification. Composition took place using conventionalized design elements such as ovoids, U forms and S forms. A composition usually fits the shape and surface being decorated. Wilson Duff states

that the final result was a high degree of conventionalism whose total effect was formal, intellectual and austere.

The "Northern Style" is a blend of the two traditions (Northern Graphic and Old Wakashan) with the conventions of Northern Graphic dominant. The work of the artist Charles Edenshaw reflects the fusion of two and three dimensional traditions.

The "Kwagiulth Style" is a combination of the free sculptural style developed before contact and surface decoration painting design elements borrowed from the "Northern Graphic" style. Their rules of colour and composition were not as strict as those of the north. It is this Kwagiulth style that is reflected in the curriculum.

ETHNOGRAPHY

Early traders and sailors transported Native "curios" all over the world and so attracted the attention of certain anthropologists.

The first serious collector of Northwest Coast art was Captain James Cook who, in his general fact-finding, included ethnographic materials. Spanish Captain Alejandro Malaspina collected specimens around 1797. Russian Captain, Urey Lisiansky, also took specimens home in 1804.

The Wilkes expedition from America (1838-41) included Northwest Coast material gleaned from a Hudson Bay trader. The son of a member of that expedition, Lt. George Thornton Emmons, USN (1852-1945) became quite an authority on Northwest Coast collecting. He and a Victoria, B.C. physician, Charles F. Newcombe collected many fine specimens which they trusted only to museums. Prior to 1930, Swann, Jacobson, George Heye, and Boas also had collected extensively.

Between 1930-1940, modernist artists "discovered" Northwest Coast art. Marius Barbeau continued to collect for Ottawa. Frederick Douglas collected for Denver, and Erna Gunther for Seattle. In Mexico, Miquel Covarrubias, Wolfgang Paalen and fellow artists collected and published privately.

Another important collector was Louis Shotridge (1886-1937), grandson of the Tlingit noble, Shartrich. He collected treasures from his own culture for Dr. George Gordon, Director of the University Museum, Philadelphia.

Franz Boas wrote about many aspects of the Northwest Coast. He wrote about Kwagiulth social organization and secret ceremonies. He also collected legends and myths. With George Hunt he wrote *Kwakiutl Texts* and Helen Codere edited his work to produce *Kwakiutl Ethnography*. His *Primitive Art* is a necessity in a collection of written work about Northwest Coast art.

Edward Curtis captured in writing and on film the culture of the Southern Kwagiulth.

NATIVE ART

RECOGNITION OF NATIVE ART AS AN ART FORM

As late as 1961, Harry Hawthorne stated that he believed Northwest Coast art was in a decline. Since then there has been a spectacular renaissance in the art with most pieces being produced for sale, with a significant number also being produced for use in revitalized native ceremonies. At present, 200 Native Northwest Coast artists are producing many items in the traditional wood and paint medium but also precious metals and in the innovative silk screening of designs. Some 20 whites and non-Northwest Coast Natives are also producing Northwest Coast style art and some have been influential in the field.

The art has evolved from "tourist" art which was inexpensive, simple and often technically flawed, to expensive, complex or sophisticated in design, innovative in style and content, and technically sound.

Some reasons for this recent and rapid evolution of art style are:

1. The promotion of Northwest Coast ethnographic art as fine art in exhibitions.
 "Arts of the Raven" 1967 (Duff)
 "Sacred Circles" 1976 (Coe)
 "Objects of Bright Pride" 1978 (Wardell)
 "The Legacy" 1971-1987 (B.C. Provincial Museum)

2. Government funding of Native Arts training programs.
 B.C. Provincial Museum Thunderbird Park carving program
 Kitanmax School of Northwest Coast Indian Art at Ksan (near Hazelton, B.C.)

3. Publication of Bill Holm's *Northwest Coast Indian Art* — an analysis of form which served as a beginning manual for artists working in the Northwest Coast style.

4. Development of more sophisticated marketing procedures through galleries and organizations like the Northwest Coast Indian Artists Guild.

More people have been interested in researching and publishing books about the art. For example:

AUTHOR	TITLE
Marius Barbeau	(on totem poles, argillite and the Haida)
Audrey Hawthorn	(on the art of the Kwakiutl and other Northwest Coast Tribes)
Robert Inverarity	(Art of the Northwest Coast Indians)
Edward Malin and Norman Feder	(Indian art of the Northwest Coast)
Marion Johnson Mochon	(Masks of the Northwest Coast)
Hilary Stewart	(Looking at Indian Art of the Northwest Coast)
Paul Wingert	(American Indian Sculpture, a Study of the Northwest Coast)
Franz Boas	(Primitive Art — on the basic meaning and interpretation of art)
Wilson Duff	(Arts of the Raven — masterworks of Northwest Coast art)
Bill Ried/Bill Holm	(Form and Freedom — dialogue on Northwest Coast art)
Erna Gunther	(Art in the Life of Northwest Coast Indians)
Claude Levi-Strauss	(Way of the Masks)
Peter MacNair et al	(Legacy — tradition and innovation in Northwest Coast art)

KWAGIULTH ARTISTS

Many artists keep alive artistic traditions by designing in their area's style. Some of the better known Kwagiulth artists are:

ARTIST	LOCATION
Bruce Alfred	Alert Bay
Beau Dick	Kingcome
Shirley Ford	Fort Rupert
Calvin Hunt	Fort Rupert
Kevin Cranmer	Victoria
Tony Hunt Jr.	Victoria
Nancy Dawson	Victoria
Victor Newman	Sooke
Henry Hunt	Fort Rupert
Richard Hunt	Fort Rupert
Tony Hunt	Fort Rupert
Russell Smith	Alert Bay
George Hunt Jr.	Fort Rupert
Doug Cranmer	Alert Bay

Willie Seaweed and the "Blunden Harbor masters" were a group of Native artists who were also influential in developing a distinctive Kwakiutl art style in the Queen Charlotte Strait area. Charlie James, Mungo Martin, and the Hunt family were also instrumental in the preservation and continuation of the Northwest Coast Art Form. They were, to a great extent, responsible for the resurgence of interest on the part of young Native artists.

SKILLS

Many of the skills are traditional, such as:

1. making carving knives – blades and handles

2. designing and painting conventional designs

3. making objects such as ceremonial dishes, spoons, bent-wood boxes, bowls, totems, fish hooks, combs, frontlets, masks, and paddles.

Some innovations exist:

1. using manufactured paint instead of natural bases plus fish oil

2. using manufactured brushes, synthetic bristles instead of natural hair

3. using some non-traditional tools (some knives, saws, etc.)

4. doing serigraphs (silkscreen prints).

5. gold and silver engraving.

INDIVIDUALLY GUIDED
EDUCATION CURRICULUM MODEL

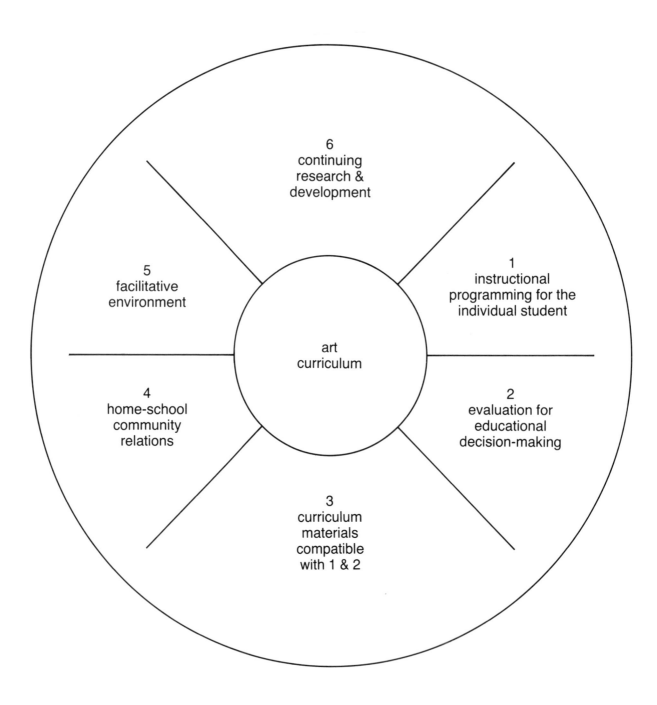

CURRICULUM

CURRICULUM MODEL

Of the eight types of individually guided education curriculum models listed by Klausmeier et al, this one can best be described as "common objectives, full mastery, and invariant sequence across units". Instructional programming for the individual student may be organized so that all students proceed through the same sequence of units, or concepts, and attain the same objectives to the same criterion of mastery. (For special students, the criterion of mastery may be subjective depending on teacher perceived ability potential.) Within the units of instruction, the objectives may or may not be sequenced invariantly. Students master sets of objectives at their own rates; not all students attain the same number of objectives during a given year. (Klausmeier, 1977, p. 63)

PATTERNS OF INSTRUCTIONAL PROGRAMMING

This curriculum follows several modes of instruction; students proceed through units of instruction by means of independent study, on a one-to-one basis, with a teacher or another student, as members of small groups or as members of a large group depending on the immediate needs of individuals or the group. (i.e., an instructor may bring in a film that the whole group sees, stopping individual work during viewing and discussion.) Small groups are teacher-directed rather than learning stations. This provides an opportunity for the dialogue that is necessary to conceptualize an area of study. Bruner states:

> ". . . culture provides aid in intellectual growth through dialogue between the more experienced and the less experienced, providing a means for the internalization of dialogue in thought."
> (Bruner, 1971, p. 89)

METHODOLOGY

Recent research in instructional and social psychology suggests that different learning contexts can create different learning processes for participants, and these in turn can influence learning outcomes. (Hiebert, 1983). Two basic types of processes involving children and teachers are allocation of time and interaction patterns.

Time

Teachers need to spend their time directly involved with children since this leads to the most achievement. (Pikulski and Kirsch, 1979) Since children are moving at different rates, many will be able to work alone or with more advanced students while the teacher sees other individuals or groups. It is possible to see most students within a class period. Care must be taken not to spend disproportionate time with just the high ability, low ability or medium ability students. The fostering of independence is also one of the objectives of this curriculum.

Research has also shown that time spent on the management of behaviour has been found to be negatively correlated with learning. (Brophy, 1979) Pupils who are mismanaging their own behaviour have diminished opportunity to receive instruction. Also, during carving, they are a danger to themselves and to those around them. One warning should be enough, then removal is warranted. Children are being offered a unique learning opportunity and pride in their efforts and in the program should be fostered.

On-task behaviour, as well as other dimensions of the learning process, has also been shown to be influenced by the difficulty of the task relative to the learner's abilities. (Good and Beckerman, 1978) This curriculum attempts to ameliorate difficulty through progressively more complex concepts, and within them, graded worksheets. Repeated practice can then be given at any level the student finds difficult. (Not so often that the student becomes bored, however. At this point it is recommended that objective completion be a cooperative effort between child and teacher with **both** of them working on the same worksheet.)

Also, the match between children's learning rates and the pace at which new information is presented has been identified as a crucial determinant of learning. (Bloom, 1976) Flexible work patterns and independence in pacing are absolute necessities in this program.

Interaction Patterns

A primary teaching technique involves the asking of questions. Especially in this program, it is important for the children to analyze their own and others work and to evaluate. Teacher questions should model behaviours that the children should use with themselves. For example, "How are these shapes and forms the same or different? How do yours compare with the master model or with recognized artists' work?", are good questions. Also, children should be given ample opportunity, through adequate time and prompts, to answer the questions themselves. No other child should be allowed to answer for the child being taught to question.

Feedback should be in terms of correct or incorrect behaviours, if possible. A general "that's good", "that could be better", is not as useful as "that line (teacher points to line) flows beautifully" or "that curve (teacher points to curve) could be changed this way." Interruptions while working either with an individual or a group should be discouraged. A pattern of interaction should be so well developed that children know someone will be there to assist them soon. Volunteers or peer help should be available at certain crucial introductory times (beginning painting, preparing wood). A group of children all demanding assistance at one time will surely disrupt learning for everyone. Pupil sheets are provided which outline procedures and have master models. They should be encouraged to use these sheets.

It is useful to be aware of the culture of the children being taught. Values of the community and of the children might affect teacher-child interaction. Eye-contact, language, amount of physical space that is comfortable, gestures and mannerisms all affect method of presentation. If children are repelled rather than attracted, it is unlikely that they are emotionally ready to receive instruction.

Learner Needs

In his essay, "Toward a Disciplined Intuition", Jerome Bruner summarizes some features of intuitive thinking that are important in various intellectual disciplines. A major goal of the curriculum is to foster the kind of thinking Bruner is discussing. His features are these: activation, confidence, visualization, non-verbal ability, the informal structuring of a task, and the partial use of available information.

1. The first requirement of any problem-solving sequence is to get started, to get behaviour out where it can be corrected, to get the learner committed to some track, to allow him to make an external summary of his internal thought processes. One of the first resistances to be overcome in problem-solving is inertia — "just sitting there", neither thinking much nor doing anything. Often a first precise move is not apparent in solving a problem or in getting an idea straight. Rather, one has the sense of a possible or estimated way of getting started.

2. While one must have some degree of self-confidence before one can make a start on a task, the act of starting itself increases one's confidence in the ability to carry the

task through. Gifted teachers report often that their minds can be used as instruments. The initial confidence of having made a start and a sense of the problem's corrigibility permits the learner, we would guess, to move on to the task of formulating hypotheses on the basis of partial evidence.

3. The paradigm or limit of most intuitive heuristics is direct perception. When a person says that at least he "sees" something, often he means that he senses it in a visualized or sensory embodiment. It is this kind of embodiment that often permits directness of grasp or immediateness. "Seeing" something, unfortunately, carries with it the often false assumption that something is as plain as seeing a thing out there.

4. It is characteristic of intuitive procedures that the person is not able to give much verbal justification of why he is or why he has made a particular discrimination. Justification in words or symbols or in manipulative proof is at least amenable to correction and closer analysis. But generally, the pure intuitive act is not so subject.

5. It is often assumed that intuitive thinking is somehow free and ungoverned. Surely this is a mistake. More likely, what we speak of as intuition is a shortcut based on an informal and often inexpressable structuring of a task.

6. Whether the person uses heuristic involving visualization or some other shorthand way of summarizing the connections inside a set of givens, he drastically reduces the range of things to which he attends. This narrowing of focus involves a kind of risk taking that requires not only a certain amount of confidence, but also a kind of implicit rule for ignoring certain information, again a risky prescience about the nature of a solution or the kind of goal one is looking for. This is what imparts directionality to the subject's problem-solving under these circumstances.

Bruner then discusses analysis and intuition. He states that analysis in a well-trained problem-solver can be just as activating as intuition, but in many cases it takes a hunch to figure our first where the analytic tools should be applied. Similarly, analysis and a sense of one's capacity to apply analytic procedures increase a problem-solver's confidence. (Bruner, 1971, p. 83-86)

Often children are convinced that they can't "do" art. They come to the class with preconceived ideas of their ability and they lack the intuitive thinking they need to begin the task of beginning somewhere. It is imperative that the teacher "thinks" out loud while she is demonstrating the concepts. The aim is to model some problem-solving strategies. Once children believe the solution (being able to draw this form) is within their grasp, they will attempt it. It may be necessary to talk them through an attempt (with physical assistance as well) to build that crucial confidence.

Supportive Environment

A supportive environment, oriented to children's particular developmental needs, is critical. Such an environment must support self-esteem by building competence as well as perceived competence. It must also support achievement motivation by building task persistence and perceived control over achievement outcomes.

If the aforementioned environment is built within the art class, the children will learn that they are in control of their own learning. Expending the effort to analyze a task and sticking to it, evaluating throughout, will bring about a beautiful, finished piece of work. Less tangible, but included in the learning, is pride, increased self-concept, an intuition of how Northwest Coast Native art "works". When they create their own designs, the mystery and the precision of the art will remain with them.

Program and Student Evaluation

Some procedures that will be followed in evaluation are listed below. Actual examples of tests, rating scales, checklists, recording devices and reporting devices will be presented in a later chapter.

1. A checklist of instructional objectives for each concept. Children are to complete all objectives before they move to the next concept.

2. Observation — the teacher will make a subjective evaluation of skills and intervene whenever necessary. It is possible to do frequency recording to record how often a student asks for help, or interrupts, or how long it takes for concepts to be completed, or how often children get started right away, or say how much they like the course. It will depend on what information the observer wants at what time.

3. Rating scales completed by students about their opinions, beliefs, attitudes, and understandings of Northwest Coast Native art and the program itself.

4. Rating scales completed by other staff members about their attitudes to the program and to their perceptions of student interest.

5. Interviews with children, parents, other concerned adults and staff.

6. Questionnaires — to parents, children, and staff that could not be interviewed.

7. Criterion referenced tests — assess cognitive information and psychomotor abilities.

Reporting

Reporting can take the form of a conference with students and/or parents. Anecdotal comments can be written and/or letter grades can be given depending on the teacher's philosophy or school's philosophy.

Present Day Development of Curriculums of Native Indian Art

In response to demand, local communities are providing teachers of the various Native Indian Arts and Crafts. Often these are skilled older people who teach using a small group/ apprentice approach. More is being published in terms of short descriptive articles of art or craft programs in diverse locations. However, details of program planning and implementation are very sketchy in the University libraries. Native people have done extensive work in planning local curriculums which have to do with language, cultural awareness, social studies and science, and reading but art curriculums appear to be in their infancy, only now being developed. (See, *Indian Education Projects in B.C. Schools* by Arthur J. More, Susan Purcell and Grace Mirehouse, Vancouver: U.B.C. Faculty of Education, 1981.)

There is a well-established carving school, the Kitanmax School of Northwest Coast Indian Art at 'Ksan, not far from Hazelton, B.C. Native artist, Bradley Hunt is developing curriculum for Sechelt and the Islands, and native artist Ross Hunt is working for the community in Fort Rupert.

Artists Jim Gilbert, George Hunt, Victor Newman and Don Yeomans are working for the School District of Victoria. Rick Nyce is working in the Hazelton area.

Locally developed curricula are not widely available but provincial conferences on Native Indian Education are bringing more and more people together to meet growing needs. The highly visible nature of Native Indian arts and crafts and the growing enthusiasm for learning, both in the Native community and out of it, is emphasizing the need for further development. This curriculum is one attempt to meet those needs.

CHAPTER THREE

GOALS AND OBJECTIVES

CHAPTER THREE

GOALS AND OBJECTIVES

An essential component of facilitating learning is the formation of goals and objectives. They provide the framework of the curriculum. They establish what is to be accomplished, how, when and where it is to be accomplished and if, or how well, it was accomplished. Goals and objectives provide direction and a means of adjusting direction.

Goals

The goals of this curriculum are:

1. To aid the non-Native Indian child to acquiring an understanding and appreciation of a culture different from his/her own.

2. To encourage a sense of dignity, equality and respect in the Native Indian child through an investigation of parts of the past and present aspects of Northwest Coast Native Indian art.

3. To promote an understanding of concerns of Native people through personal contact between Native and non-Native children and adults, and through understanding of the accomplishments of Native people in the past and in the present.

4. To have the child become knowledgeable about a number of materials, tools, and techniques which were developed and used by Native artists.

5. To aid all children in acquiring an understanding and appreciation of a truly unique, complex art form.

The general goals for the child are:

In relation to himself/herself

To encourage the child to:

1. Develop a feeling of adequacy and self-respect by gaining recognition as a unique individual.

2. Develop a favourable attitude to the learning of Northwest Coast Native Indian art by experiencing success and by learning to deal effectively with corrective feedback.

3. Develop some independence by making his/her own choices and decisions while feeling free to go to adults for assurance and help.

4. Develop a sense of responsibility by caring for his/her own possessions and those that belong to others.

5. Develop habits of orderliness.

In relation to other people

To encourage the child to:

1. Develop a respect for other children and adults.

2. Develop sympathy and tolerance for the shortcomings of others.

3. Improve his/her perception of the emotions and feelings of others.

4. Learn how to work in and with a group.

5. Develop an acceptance and enjoyment of other children and at the same time feel accepted by them.

In relation to the environment

To encourage the child to:

1. Improve his/her coordination by manipulative activity.

2. Learn the correct use of a variety of materials and equipment.

3. Seek and accept responsibility in sharing the work in keeping the place where he/she works in a suitable condition.

In relation to the world of ideas

To encourage the child to:

1. Seek many opportunities for experiences which arouse curiosity and enthusiasm.

2. Have adventures with new ideas and new places to experiment, test, discover and take excursions.

3. Sharpen and use the senses of hearing, seeing and touching.

4. Do some planning — think, make decisions, work, and follow through.

5. Discuss, question, gather, list, label, seriate, classify, organize information and draw conclusions.

6. Search for and recognize similarities and differences.

7. Search for sequences and patterns, and predict outcomes.

Objectives

The objectives of the curriculum are grouped as follows:
The child will be able to:

1. Define the concepts.

2. List the characteristics of the concept.

3. Label a drawing with its characteristics.

4. Compare and contrast different concepts.

5. Analyze and recognize correctly and incorrectly drawn examples of concepts.

6. Evaluate and correct his/her own completion of a concept.

7. Complete a concept using drawing, painting, carving and other technical skills.

8. Complete an incomplete drawing.

9. Answer some literal and inferential questions about what he/she has learned, orally and in writing.

10. Follow spoken and written directions.

11. Care for the equipment and space in which he/she is working.

More specific objectives are listed under concept titles.

EVALUATION

Another essential component of facilitating learning is evaluation. It will pinpoint effective or weak strategies as well as those that are still needed. In these days of limited resources (time, money, personnel, materials, motivation), only the most effective, efficient strategies should be used to assure learning.

Evaluation provides:

1. Feedback to the teacher.
 a. to improve the program.
 b. to determine a child's readiness for new work.
 c. to determine areas of a child's difficulties.

2. Feedback to the student.
 a. to judge and adjust his/her performance.
 b. to motivate.
 c. to increase self-awareness.

3. Feedback to the home and community.
 a. to report the progress of the child.
 b. to increase awareness of the abilities of the child.
 c. to provide for the individual needs of the child.
 d. to determine the best allocation of resources.
 e. to increase home and community awareness of the program created to assist the child.

There are several characteristics of an effective evaluation program:

1. It is based on clear and specific objectives.

2. It is continuous and cumulative, with records kept by teachers and shared to the benefit of the child.

3. It measures in the affective as well as the cognitive domain.

4. It includes teachers, students, parents/guardians, and administrators, counsellors, aides and the community.

5. It includes evaluation of means as well as ends.

6. It is wisely interpreted to students, parents/guardians and others who are concerned.

7. It considers the individual abilities of each child.

8. It includes experimentation with new methods and ideas.

Name: _____ Date: _____

RATING SCALE

TEACHER PROGRAM EVALUATION

1. I think the children who are going to the Native Indian art program are enjoying it.

1	2	3	4	5
A	Quite	Some	A	Not
lot	a lot		little	at all

2. I think the children have learned from participating in the art class.

1	2	3	4	5
A	Quite	Some	A	Not
lot	a lot		little	at all

3. I can see an increase in skill abilities.

1	2	3	4	5
A	Quite	Some	A	Not
lot	a lot		little	at all

4. I can see an increase in positive self-concept.

1	2	3	4	5
A	Quite	Some	A	Not
lot	a lot		little	at all

5. The children who are going to the art class are missing class instruction time.

1	2	3	4	5
A	Too	Some	A	It is planned
lot	much		little	into my
				instruction

6. I think both Native Indian children and non-Native children are benefiting by the exposure to an aspect of Native Indian culture and to Native Indian personnel.

1	2	3	4	5
A	Quite	Some	A	Not
lot	a lot		little	at all

7. I have learned more about Native Indian art through my students.

1	2	3	4	5
A	Quite	Some	A	Not
lot	a lot		little	at all

8. I would like to know more about the art program.

1	2
Yes	No

COMMENTS _____

Thank you very much for taking the time to complete this rating scale. I very much appreciate this and any other feedback you care to offer about the Native Indian Art Program.

Teacher signature _____

Name: _____ Date: _____

RATING SCALE

PARENT/GUARDIAN EVALUATION

Your child/children have been learning more about Native Indian art by participating in the art course at the school. I would appreciate you filling our this form so that I will be able to tell how you and your child/children feel about the program. THANK YOU!

Teacher signature _____

1. I think my child enjoys the Native Indian art course.

1	2	3	4	5
A	Quite	Some	A	Not
lot	a lot		little	at all

2. I think my child has learned from participating in the Native Indian art course.

1	2	3	4	5
A	Quite	Some	A	Nothing
lot	a lot		little	

3. My child brings projects home to work on or to show me.

1	2	3	4	5
A	Quite	Sometimes	Rarely	Never
lot	a lot			

4. My child talks to me about the Native Indian art course.

1	2	3	4	5
A	Quite	Some	A	Never
lot	a lot		little	

5. I would like to know more about the Native Indian art course.

1	2
Yes	No

6. If "yes", (1) I will phone you at the school to set up an appointment. ____
 (2) Please phone me at _____ to set up an appointment. ____

7. Comments _____

 Signature: _____

Name: _____ Date: _____

QUESTIONNAIRE

TEACHER SELF-EVALUATION

1. Did I prepare and preplan adequately for instruction?

2. Did I clearly state and explain the objectives?

3. Did I model the behaviour adequately and often enough?

4. Did I use appropriate methods to attain the objectives?

5. Were activities organized and sequenced?

6. Did activities flow smoothly?

7. Would other materials and media have worked better? Specify changes.

8. Did I have options in the event of failure?

9. Did I actively provide corrective feedback? (using prompts and cues as well as modelling to encourage students to self-evaluate)

10. Did I involve Native artists and the community?

11. Did I make the child feel competent as a learner?

12. Did I allow enough discussion to facilitate the goals of understanding and appreciation?

13. Did I keep complete and careful records?

14. Did I report the progress of the course and the child adequately?

Name: _____ Date: _____

RATING SCALE

STUDENT SELF-EVALUATION

1. In the art class, I learned:

1	2	3	4	5
A lot	Quite a lot	Some	A little	Nothing

2. I found the work:

1	2	3	4	5
Hard		Medium		Easy

3. I needed help:

1	2	3	4	5
A lot	Quite a lot	Sometimes	Rarely	Never

4. I got better at the skills as I practiced:

1	2	3	4	5
Always	Usually	Sometimes	Rarely	Never

5. I felt comfortable asking for help when I needed it:

1	2	3	4	5
Always	Usually	Sometimes	Rarely	Never

6. My teacher made me feel good about my progress:

1	2	3	4	5
Always	Usually	Sometimes	Rarely	Never

7. During class time, I worked to the best of my ability:

1	2	3	4	5
Always	Usually	Sometimes	Rarely	Never

8. I would like to learn more about Native Indian art:

1	2	3	4	5
Yes		Maybe		No

9. I think other students would learn from it:

1	2	3	4	5
Yes		Maybe		No

I would have learned more if _____

Name: _____ Date: _____

QUESTIONNAIRE

STUDENT COURSE EVALUATION

To help make this course the best it can be, it would help me if you would give me your evaluation.

1. What do you like best about the course?

2. What materials or teaching methods should be changed?

3. Which concept did you find the easiest? Why?

4. Which concept was the most difficult? Why?

5. Which skill did you find the most difficult to learn? (drawing, painting, carving, mounting your work)

6. What helped you most when you were learning new skills and concepts? Please check.

 student sheets _____ teacher explanation and modelling
 before you began _____

 teacher explanation and modelling worksheets _____
 while you were working _____

 your own ability to check and correct a friend who already knew the skill _____
 your work _____

 the teacher believing you could you believing you could do it _____
 do it _____

 Other _____

7. What would you like to see more of? Please check.

 Films _____ Field trips _____
 Demonstrations by artists _____ Additional concepts _____
 Discussions _____ Work time _____

 Other _____

Name: _____

NORTHWEST COAST INDIAN ART - page 1
Criterion Referenced Test

Print on lines the name of the form/shape.

1.

Name of Unit _____

2.

Colour _____

Name of Unit _____

3.

 Colour _____
Colour _____

Name of Unit _____

4.

In the Northwest Coast Indian art this unit can be used to represent:

a. _____

b. _____

Name of Unit _____

5.

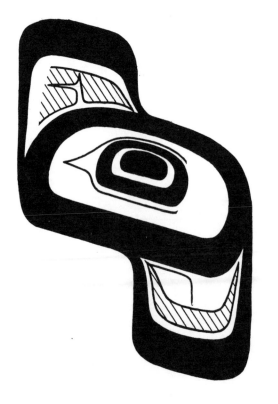

Name three basic units found in this design unit

1. _____

2. _____

3. _____

Draw in missing lines
Where in Northwest Coast art is this painted design unit often seen?

Name of Unit _____

NORTHWEST COAST INDIAN ART - page 2

6. Draw in missing lines.

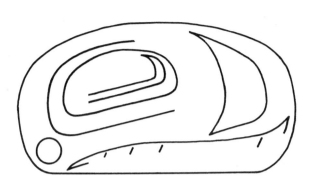

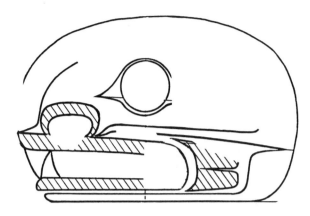

Name of Unit _____ Name of Unit _____

1. Three colours that are used in Northwest Coast Indian art are _____,_____,_____.

2. Name two blade types used in carving knives _____,_____.

3. Two different kinds of woods used for carving Indian art are _____ and _____.

4. Name two Northwest Coast Indian artists: 1. _____ 2. _____.

5. Name two different tribes on the British Columbia coast: 1. _____ 2. _____.

Using the above dots as guide lines or outline shape draw a head of an animal, bird or fish.
Drawn lines can be inside or outside dotted line. Do not draw salmon, trout or whale head.

33

Name: _____

NORTHWEST COAST INDIAN ART - page 3

Name the following concepts

1. _____ 6. _____ 11. _____
2. _____ 7. _____ 12. _____
3. _____ 8. _____ 13. _____
4. _____ 9. _____ 14. _____
5. _____ 10. _____ 15. _____

1.

2.

5.

10.

6.

9.
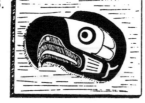

11.
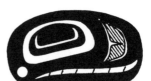

7.
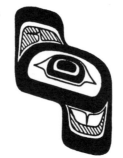

4.

3.
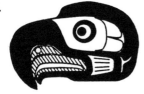

13.

12.
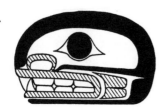

8.
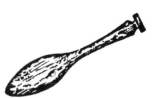

14.

6.

15.
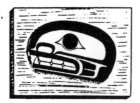

34

CONCEPT

CHECKLIST

CONCEPT

NAME	#	#	#	#	#	#
1.						
2.						
3.						
4.						
5.						
6.						
7.						
8.						
9.						
10.						
11.						
12.						
13.						
14.						
15.						
16.						
17.						
18.						
19.						
20.						
21.						
22.						
23.						
24.						
25.						

NOTES:

GROUP RECORD CARD
CONCEPT _____

NAME														

CONCEPT OBJECTIVE
(circle one) The child will be able to:

1. define the concept
2. list the characteristics of the concept
3. label a drawing with its characteristics
4. compare and contrast different concepts
5. analyze and recognize correctly and incorrectly drawn examples
6. evaluate and correct his/her own completion of a concept
7. complete a concept using drawing, painting, carving and other technical skills
8. complete an incomplete drawing
9. answer some literal and inferential questions about what he/she has learned, orally and in writing
10. follow spoken and written directions
11. care for the equipment and space in which he/she is working

1
2
3
4
5
6
7
8
9
10
11
12
13
14
15

36

CHAPTER FOUR

TEACHING/LEARNING THE CONCEPTS AND SKILLS

NATIVE INDIAN ART DISPLAYS

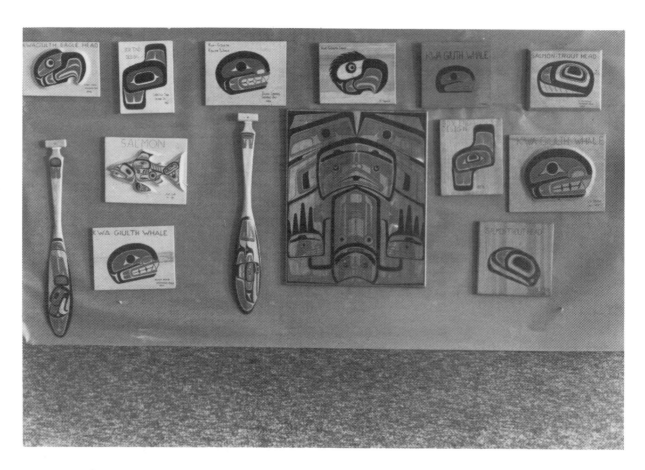

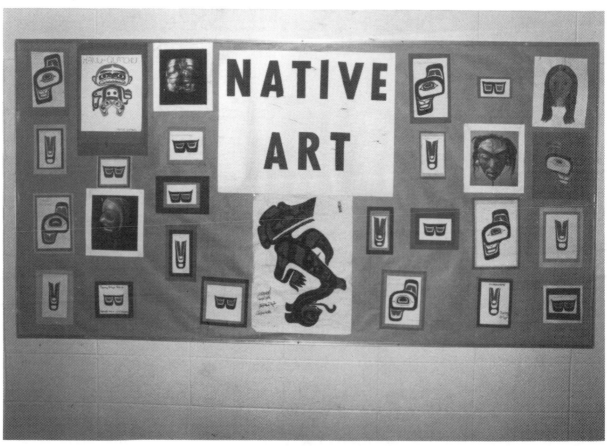

CONCEPT #1
BASIC OVOID
(T.S.)

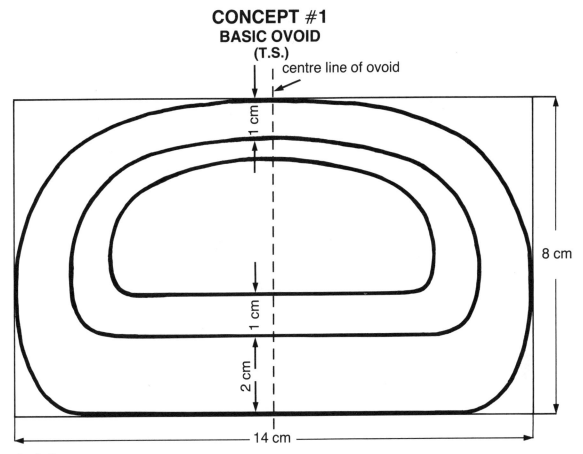

centre line of ovoid

1 cm

1 cm

2 cm

8 cm

14 cm

Characteristics:

1. Basic Outline
 symmetrical shape
 — same shape both sides
 a. flat bottom
 b. curved top
 c. out-curved ends
2. Formline
 — outer ovoid - black - *wider on bottom than top
 — inner ovoid - black

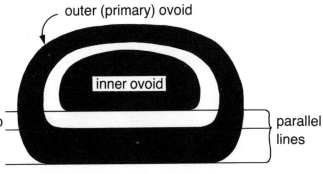

outer (primary) ovoid

inner ovoid

parallel lines

Objectives:

The student will be able to:

1. describe an ovoid
2. recognize and state the names of the characteristics (black form line, outer (primary) ovoid, inner ovoid, parallel lines).
3. label the characteristics when given a diagram of a painted ovoid.

4. use ruler or measuring device to mark her own reference points and lines.
5. check her drawing for symmetry by folding her drawing in half vertically.
6. correct his work to the best of his ability before seeking out confirmation from the teacher.
7. given examples, distinguish between a correctly and incorrectly drawn ovoid.
8. complete all necessary worksheets.
9. reproduce a conventional Kwagiulth ovoid using the rules developed during the use of the worksheets.
10. colour the formline and inner ovoid black.
11. use the term "ovoid" when speaking of this concept.
12. point out ovoids in a complete design.

CONCEPT #1
BASIC OVOID
(S.S.)

centre line of ovoid

1 cm

1 cm

2 cm

8 cm

14 cm

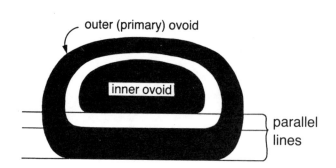

outer (primary) ovoid

inner ovoid

parallel lines

Characteristics:
1. Basic Outline
 symmetrical shape
 — same shape both sides
 a. flat bottom
 b. curved top
 c. out-curved ends
2. Formline
 — outer ovoid - black - *wider on bottom than top
 — inner ovoid - black

Activities:
1. Complete worksheets a, b, c, d.
2. On worksheet 'e', measure and mark out all reference points and the reference rectangle.
3. Draw an ovoid on a separate sheet of paper, using a reference rectangle.
4. Colour your ovoid according to the master sample.
5. Look at a complete design and point out the ovoids.
6. Describe what an ovoid looks like.
7. Label your finished drawing using the terms "basic ovoid", "black formline", "outer or primary ovoid", "inner ovoid", and "straight parallel lines".
8. Look at some examples of correctly and incorrectly drawn ovoids. Pick out the correct ones and explain why the others are incorrect.

Materials:
Paper, pencil, eraser, ruler, black pencil crayon, worksheets and master sheet.

BASIC OVOID
WORKSHEET "a"

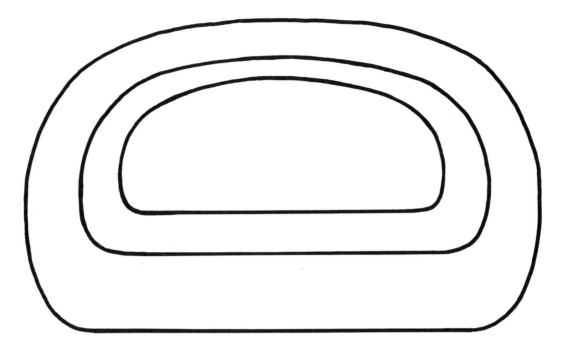

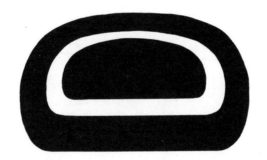

Connect the dots.

BASIC OVOID
WORKSHEET "b"

Fill in the missing lines.

BASIC OVOID
WORKSHEET "c"

Draw in the missing half.

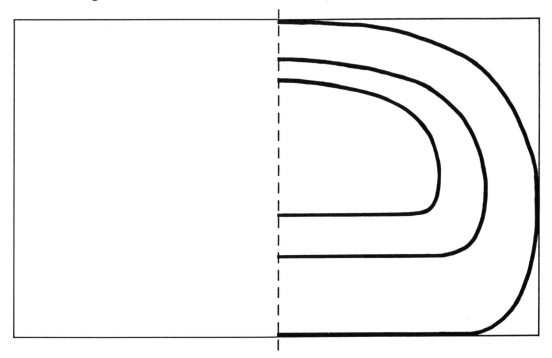

BASIC OVOID
WORKSHEET "d"

draw in this half of the ovoid centre line

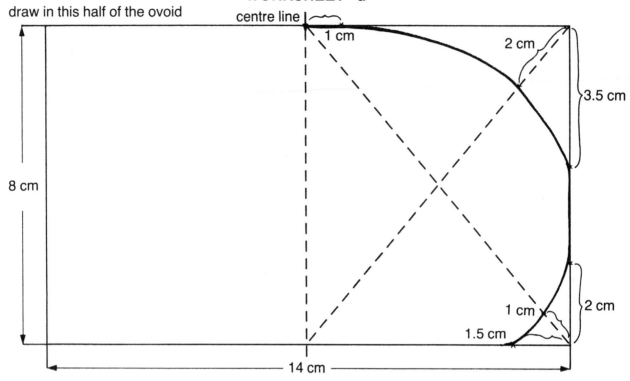

1 cm

2 cm

3.5 cm

8 cm

2 cm

1 cm

1.5 cm

14 cm

centre line of ovoid

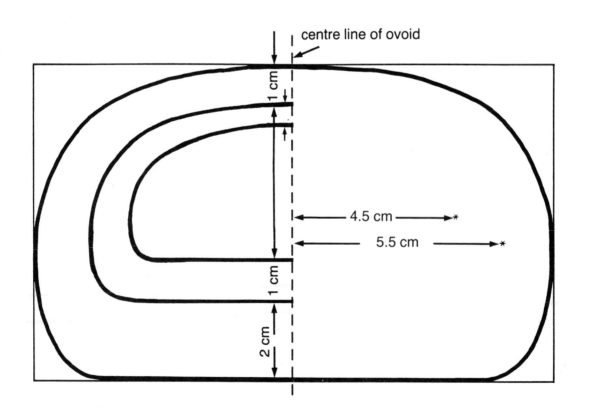

1 cm

1 cm

4.5 cm

5.5 cm

1 cm

2 cm

BASIC OVOID
WORKSHEET "e"

Measure and mark reference points.

Now make your own guidelines and reference points.

DRAWN PRIMARY OVOID PAINTED PRIMARY OVOID

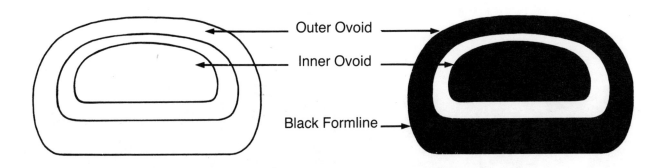

Outer Ovoid

Inner Ovoid

Black Formline

COMPLETED WHALE FIGURE
Identify ovoids.

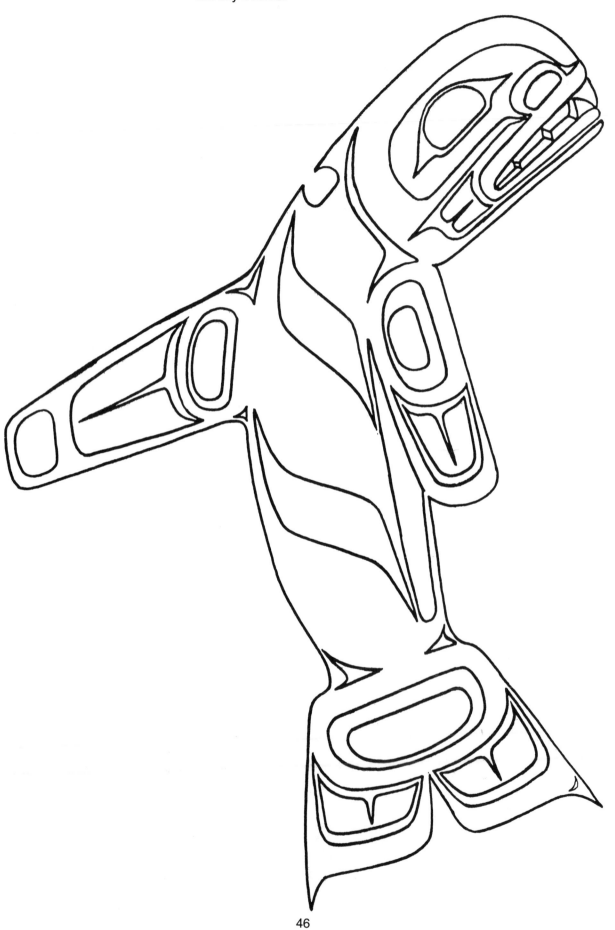

BASIC OVOID
WORKSHEET "f"

Fill in missing ovoids and eyelid line.

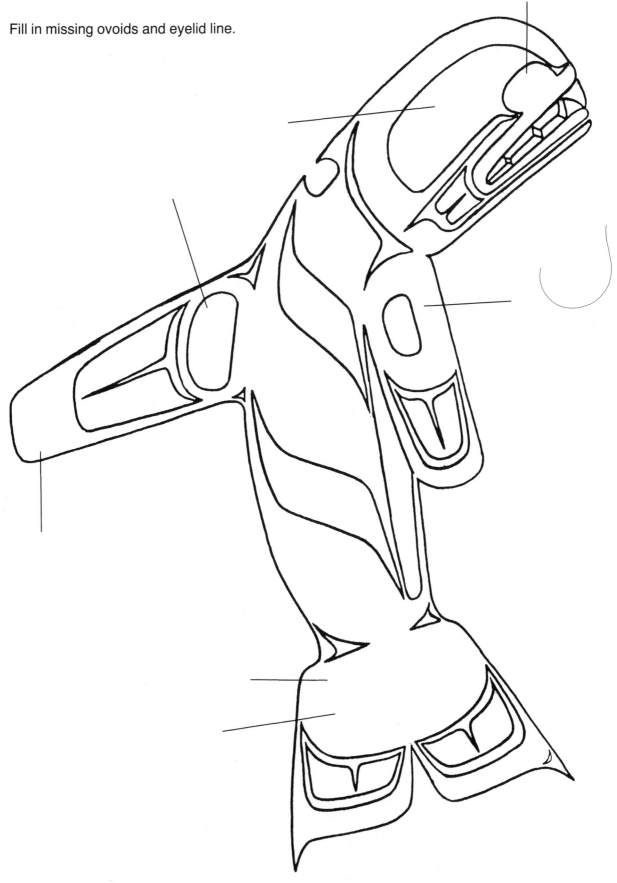

WHALE SHOWING OVOID COMPOSITION

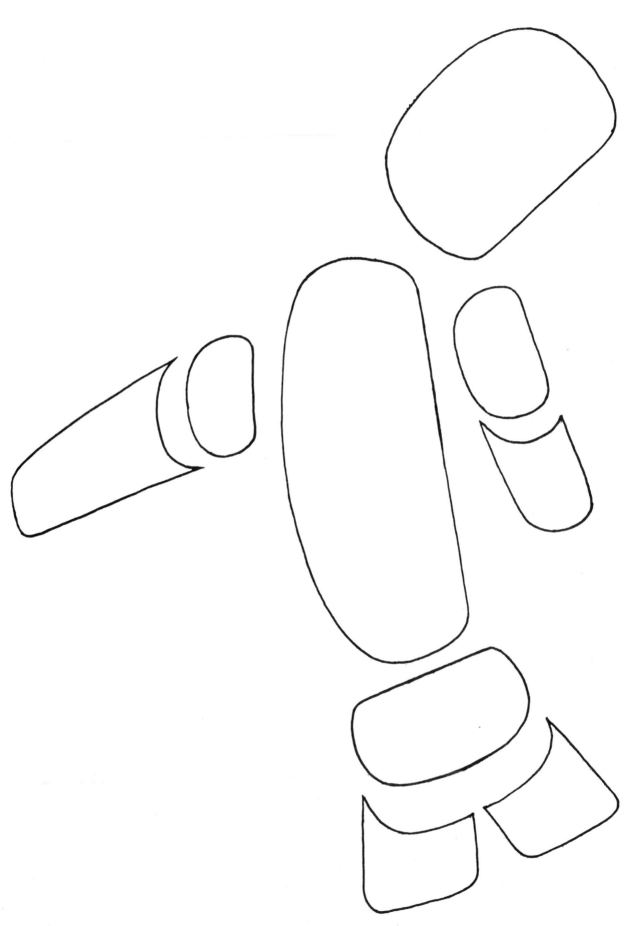

CORRECTLY DRAWN AND CORRECTLY PAINTED OVOID

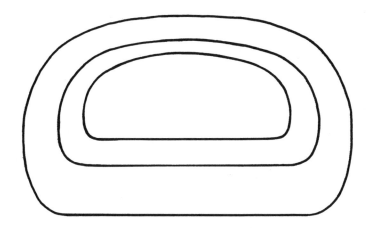

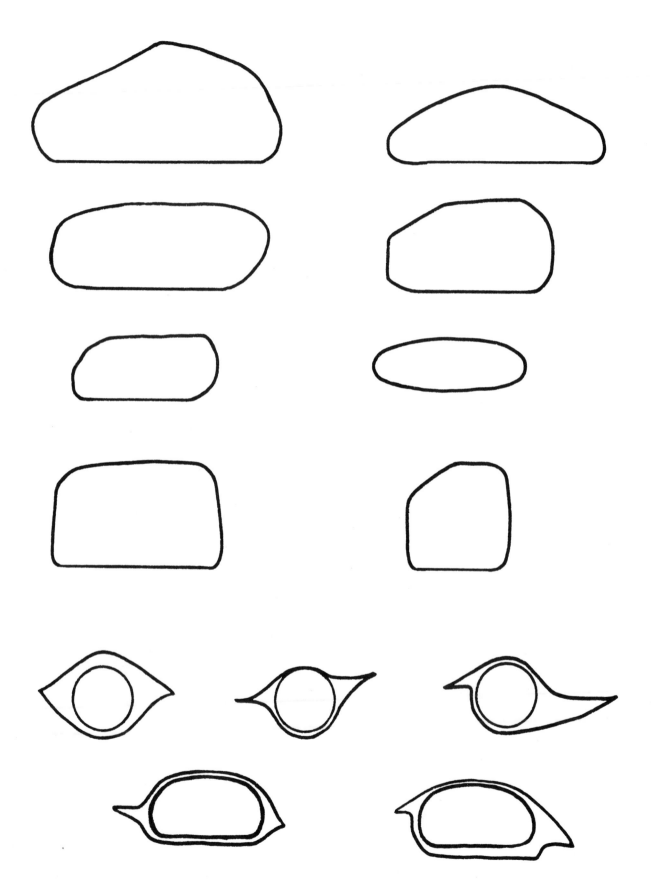

NUU CHAH NULTH (NOOTKA)
(WEST COAST)
OVOID

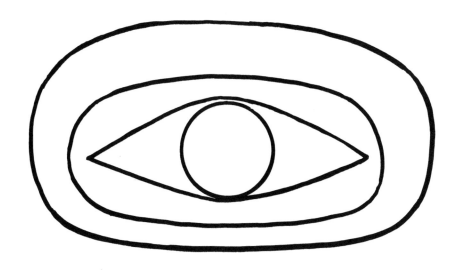

OVOID WITH EYELID

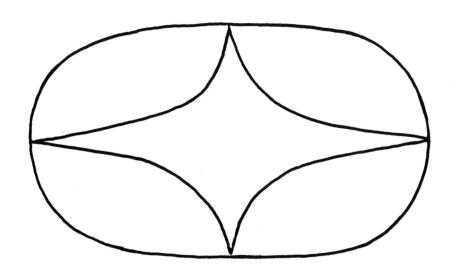

BASIC 4 SPLIT (STAR) OVOID

CONCEPT #2
OVOID WITH EYELID LINE
(T.S.)

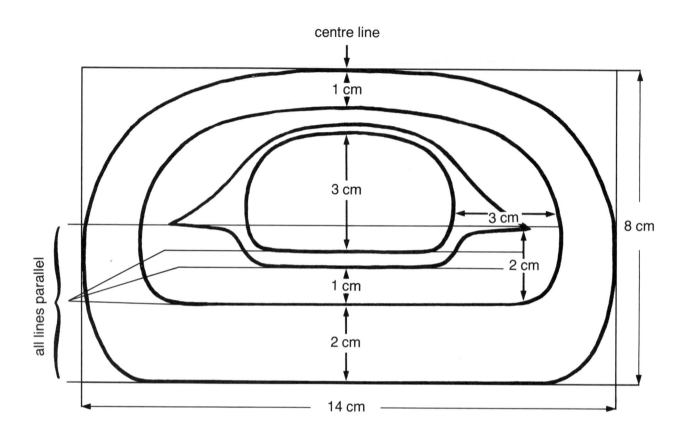

Characteristics:
1. Basic Outline
2. Formline
3. Inner Ovoid
4. Eyelid line (fine line)

Objectives:
1. See objectives in Concept #1.

The student will be able to:
2. Recognize and state the differences between Concept #1 and Concept #2. (eg. size of inner ovoid, or eyelid line)
3. Recognize and state the similarities between Concept #1 and Concept #2.
4. Identify and label a given drawing "ovoid with eyelid line".

CONCEPT #2 — COMPONENT SHEET — INNER OVOID AND EYELID LINE

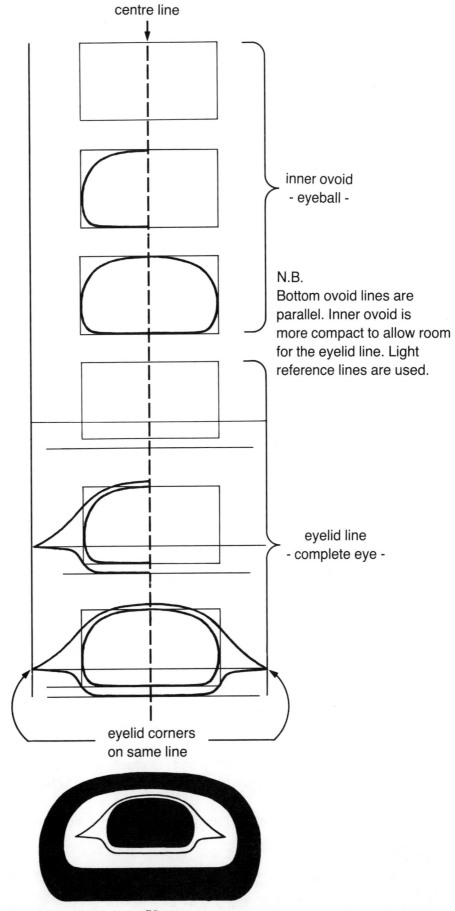

centre line

inner ovoid
- eyeball -

N.B.
Bottom ovoid lines are parallel. Inner ovoid is more compact to allow room for the eyelid line. Light reference lines are used.

eyelid line
- complete eye -

eyelid corners
on same line

CONCEPT #2
OVOID WITH EYELID LINE
(S.S.)

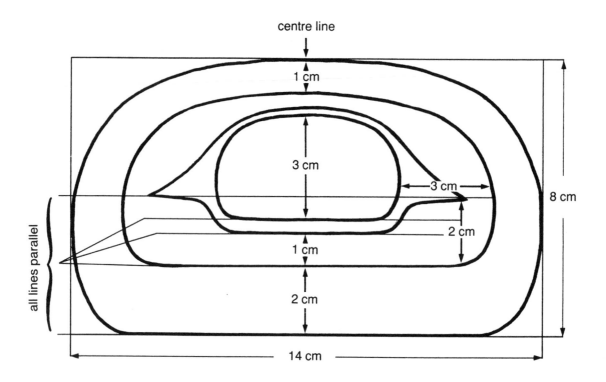

Characteristics:
1. Basic Outline
2. Formline
3. Inner Ovoid
4. Eyelid Line (fine line)

Activities:
1. Complete worksheets a, b, c, d.
2. Draw an ovoid with eyelid line on a separate sheet using the measuring techniques you have learned.
3. Colour your ovoid according to the master example.
4. Look at a complete design and point out any ovoids with eyelid lines.
5. Describe an ovoid with an eyelid line.
6. Label your finished drawing using the terms "ovoid with eyelid line", "formline", "outer or primary ovoid", "inner ovoid", "straight parallel lines", and "eyelid line".
7. Look at some examples of correctly and incorrectly drawn ovoids with eyelid lines. Pick out the correct ones and explain how the others would have to be changed in order to be correct.
8. Tell how Concepts #1 and #2 are alike and how they are different.

Materials:
Paper, pencil, eraser, ruler, black pencil crayon, five worksheets and master example sheets.

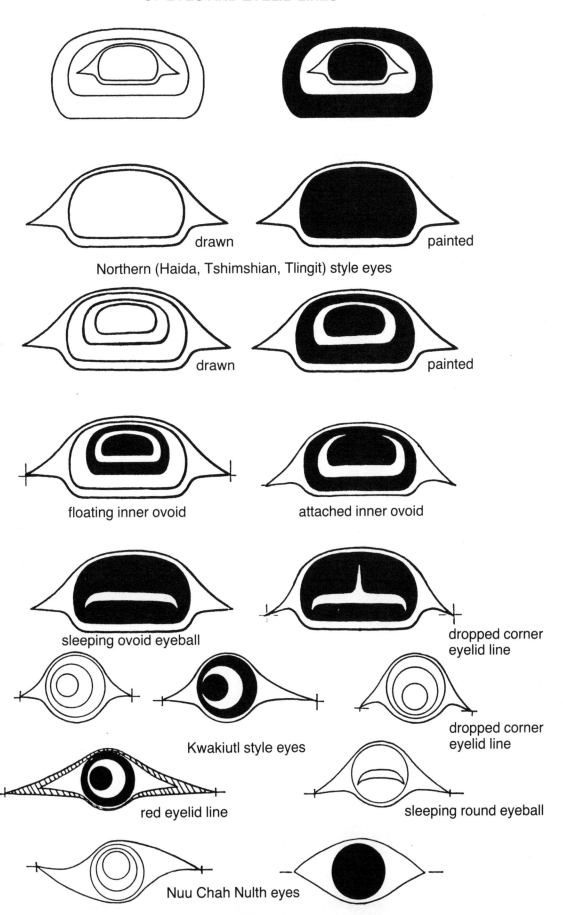

drawn

painted

Northern (Haida, Tshimshian, Tlingit) style eyes

drawn

painted

floating inner ovoid

attached inner ovoid

sleeping ovoid eyeball

dropped corner eyelid line

Kwakiutl style eyes

dropped corner eyelid line

red eyelid line

sleeping round eyeball

Nuu Chah Nulth eyes

OVOID WITH EYELID LINE
WORKSHEET "a"

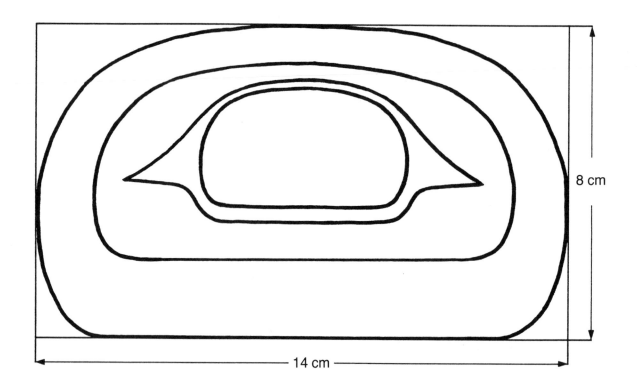

8 cm

14 cm

Connect the dots

OVOID WITH EYELID LINE
WORKSHEET "b"

Fill in the missing lines.

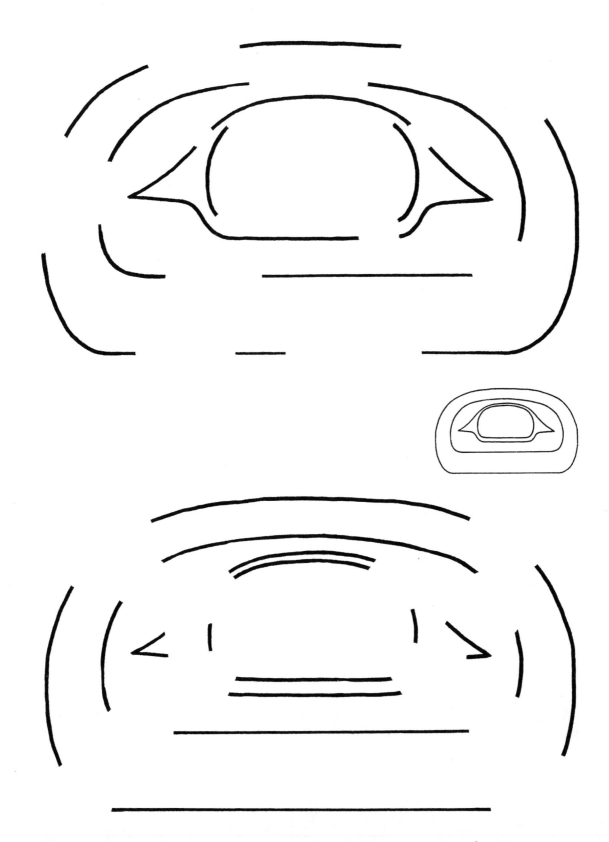

57

OVOID WITH EYELID LINE
WORKSHEET "c"

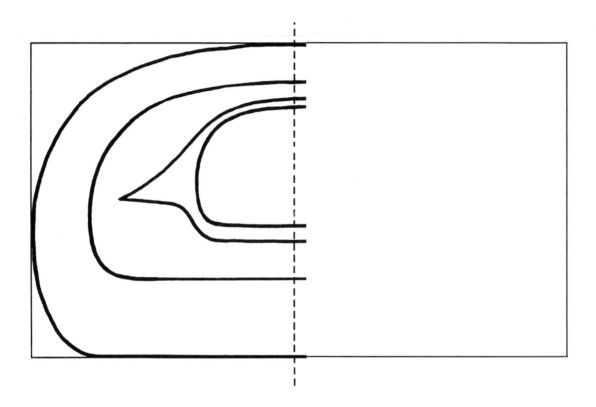

Complete using reference dots and lines.

Name: _____

OVOID WITH EYELID LINE
WORKSHEET "d"

centre line

14 cm

Now make your own guidelines and reference points.

CONCEPT #3
'U' SHAPE
(T.S.)

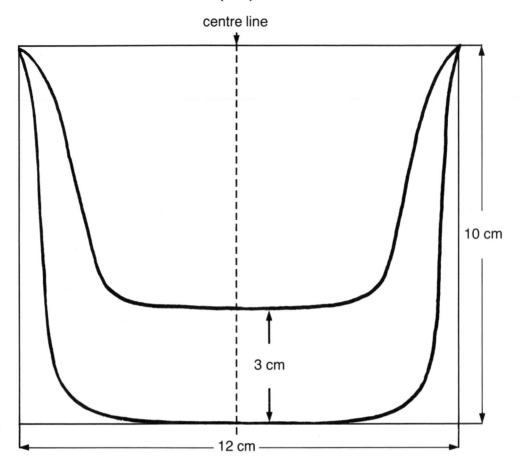

centre line

10 cm

3 cm

12 cm

Characteristics:
1. 'U' Shape.
2. Formline.
3. Formline tapers at the top.
4. Wide line at the bottom.
5. Flat bottom.
6. Curved corners.
7. Centre line.

Objectives:
The student will be able to:
1. describe a 'U' Shape.
2. use a ruler or measuring device to mark reference points and lines.
3. check drawing for symmetry by folding drawing in half vertically.
4. correct work to the best of her ability before seeking out confirmation from the teacher.
5. given examples, distinguish between a correctly and incorrectly drawn 'U' Shape.
6. complete all necessary worksheets.
7. use developed rules to draw a conventional Kwagiulth 'U' Shape.
8. colour the formline black.
9. use the term 'U' Shape when speaking of this concept.
10. point out 'U' Shapes in a complete design.

CONCEPT #3
'U' SHAPE
(S.S.)

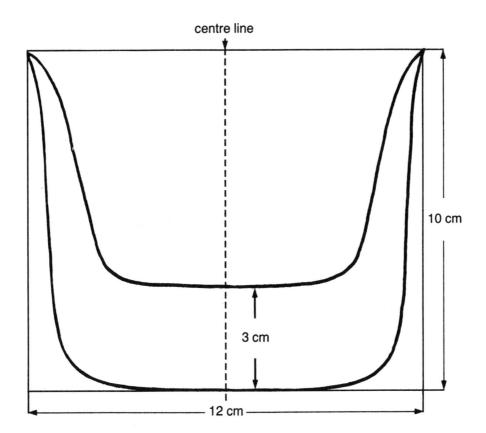

Characteristics:
1. 'U' Shape.
2. Formline.
3. Formline tapers at the top.
4. Wide line at the bottom.
5. Flat bottom.
6. Curved corners.
7. Centre line.

Activities:
1. Complete worksheets.
2. Draw a 'U' Shape on a separate sheet of paper using the measuring techniques you have learned.
3. Colour your 'U' Shape according to the master example sheet.
4. Look at a complete design and point out any 'U' Shapes.
5. Describe a 'U' Shape.
6. Label your finished drawing using the terms: "'U' Shape", "black formline".
7. Look at some examples of correctly and incorrectly drawn 'U' Shapes. How would the incorrectly drawn ones have to be changed in order to be correct?

'U' SHAPE
WORKSHEET "a"

centre line

10 cm

3 cm

12 cm

Connect the dots

Name: _____

'U' SHAPE
WORKSHEET "b"

Fill in the missing lines.

'U' SHAPE
WORKSHEET "c"

Draw in the missing half.

'U' SHAPE
WORKSHEET "d"

Measure and mark reference points.

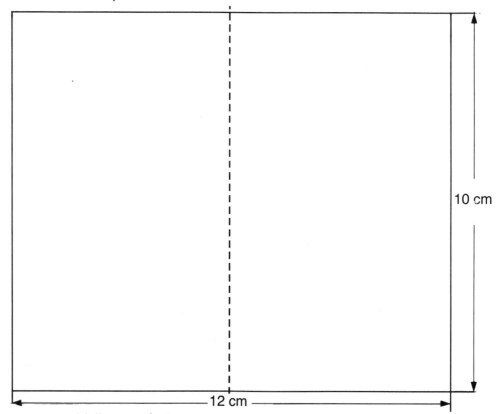

10 cm

←————————— 12 cm —————————→

Now make your own guidelines and reference points.

Name: _____

'U' SHAPES AND OVOIDS
WORKSHEET "e"

Join basic shapes using a formline and concept definition lines. (see Completed Whale Figure in Concept #1)

CONCEPT #4
SPLIT 'U'
(T.S.)

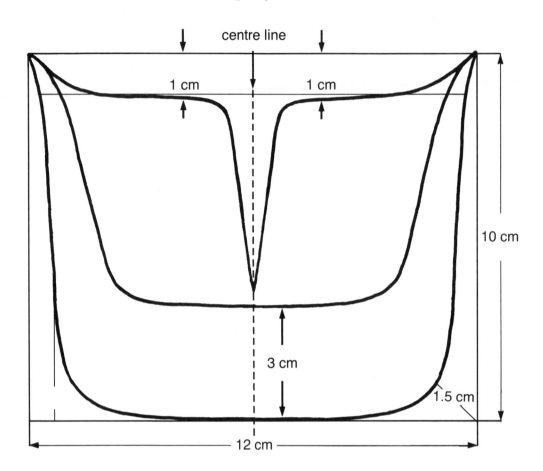

Characteristics:
1. 'U' Shape.
2. Formline - black
3. Split - fine line.

Objectives:

The student will be able to:

. 1. recognize and state the similarities and differences between a 'U' Shape and a Split 'U'.
2. list at least five things 'U' Shapes can represent (eg. fins, feathers, flukes, scales, tails, beaks, ears, flippers and fingers).
3. label a given drawing "Split 'U' Shape".
4. use ruler or measuring device to mark reference points and lines.
5. check drawing for symmetry by folding drawing in half vertically.
6. correct work to the best of his ability before seeking out confirmation from the teacher.
7. given examples, distinguish between a correct and incorrect 'U' Shape.
8. complete all necessary worksheets.
9. use developed rules to draw a conventional Kwagiulth Split 'U'.
10. colour the formline black, and the thin, fine line split, red.
11. use the term "Split 'U'" when speaking of this concept.
12. point out Split 'U' Shapes in a complete design.

CONCEPT #4
SPLIT 'U'
(S.S.)

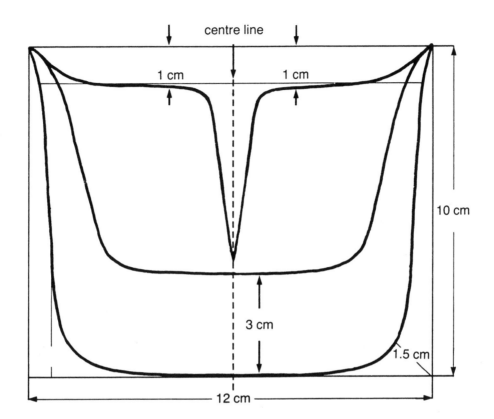

Characteristics:
1. 'U' Shape.
2. Formline - black.
3. Split - fine line.

Activities:
1. Complete worksheets a, b, c, d.
2. Draw a Split 'U' on a separate sheet of paper using the measuring techniques you have learned.
3. Colour your Split 'U' according to the master example sheet.
4. Look for a complete design and point out any Split 'U' Shapes.
5. Describe a Split 'U'.
6. Label your finished drawing using the terms: "Split 'U'", "black formline", "Split fine red line".
7. Tell which examples of Split 'U's are correctly drawn and why.
8. Tell how a 'U' Shape and a Split 'U' are alike and different.
9. Tell five things that 'U' Shapes can represent.

Materials:
Pencil, paper, eraser, ruler, black pencil crayon, red pencil crayon, worksheets and master example sheet.

SPLIT 'U'
WORKSHEET "a"

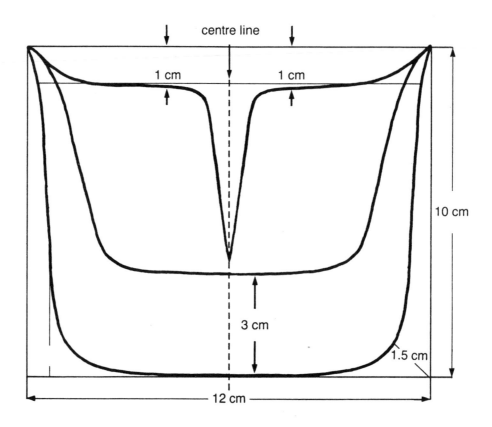

Connect the dots

SPLIT 'U'
WORKSHEET "b"

Fill in the missing lines

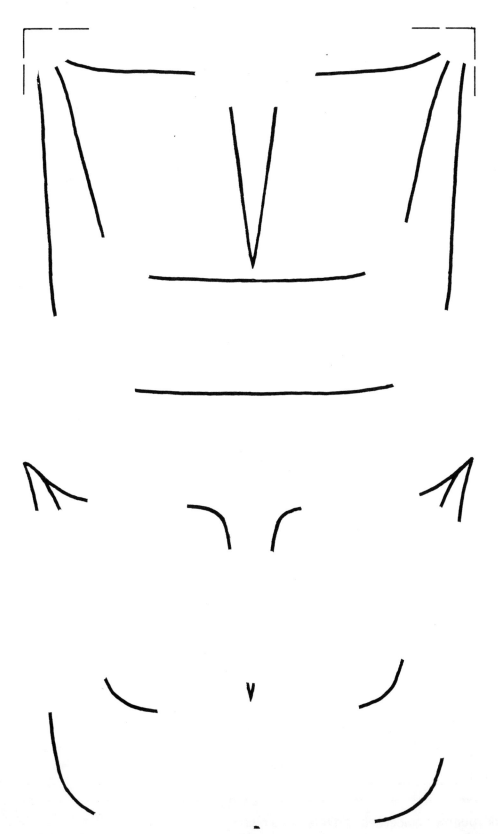

SPLIT 'U'
WORKSHEET "c"

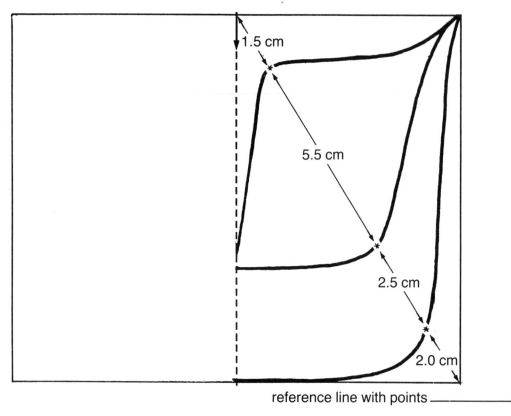

1.5 cm

5.5 cm

2.5 cm

2.0 cm

reference line with points _____

SPLIT 'U'
WORKSHEET "d"

Measure and mark reference points.

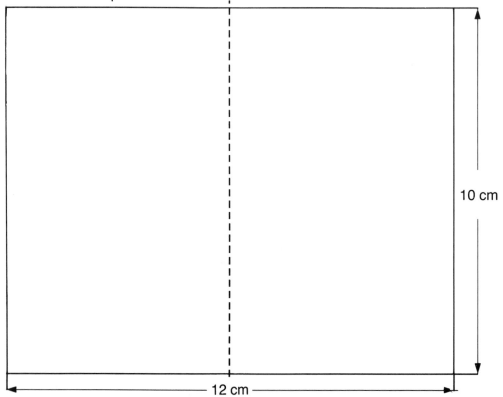

10 cm

12 cm

Now mark your own guidelines and reference points.

SPLIT 'U' VARIATION
(Solid red filler instead of red fine line)

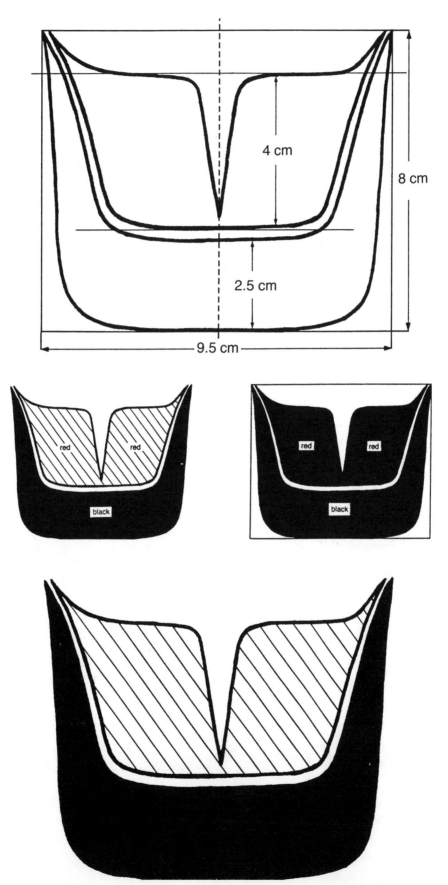

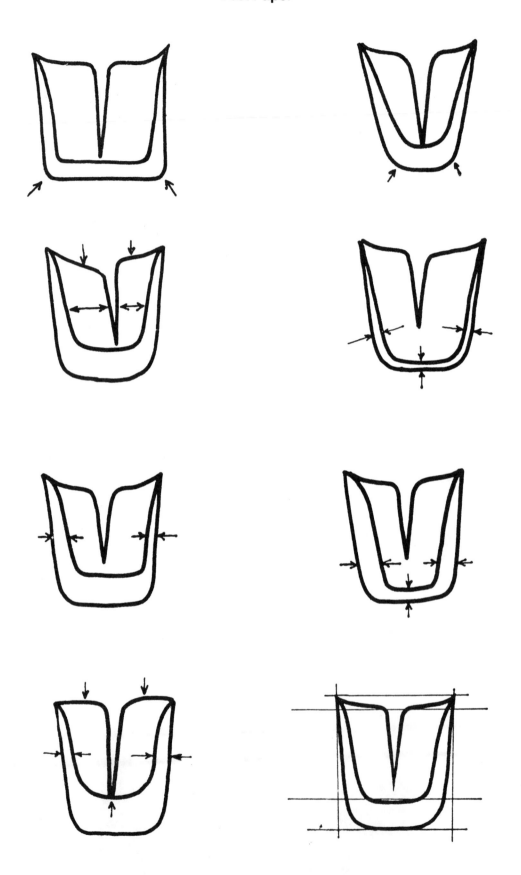

SPLIT 'U' FORMS: COMMON MISTAKES

too square

too round

— crooked split
— uneven

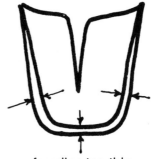

formline too thin

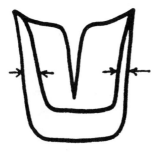

one side too thin

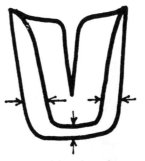

sides wider than bottom

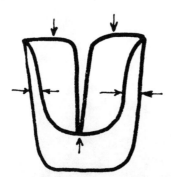

— split too round
— split touching bottom

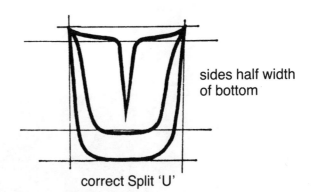

correct Split 'U'

sides half width of bottom

CONCEPT #5
REVERSE SPLIT 'U'
(T.S.)

centre line

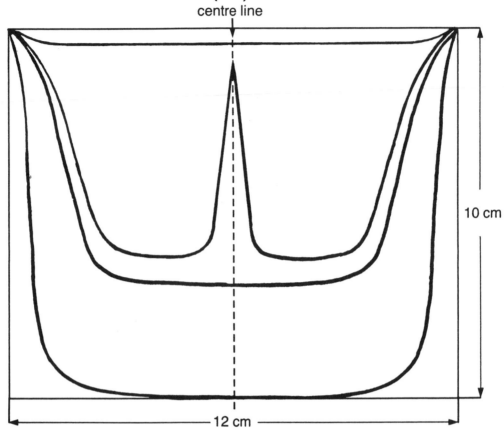

10 cm

12 cm

centre line

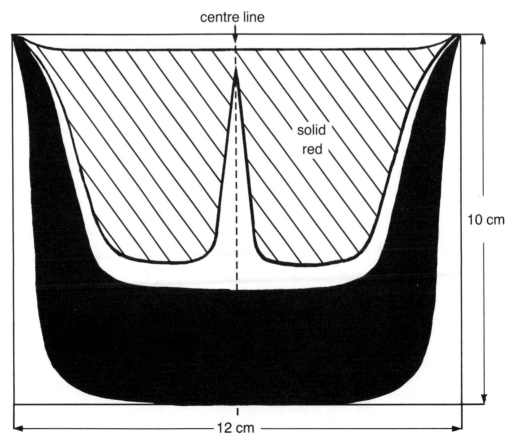

solid
red

10 cm

12 cm

CONCEPT #5
REVERSE SPLIT 'U'
(T.S.)

Characteristics:
1. 'U' Shape.
2. Formline - black
3. Reverse Split 'U' *(secondary filler unit)
4. Secondary Reverse Split 'U' cannot touch black primary formline 'U' except at tapered ends.

Objectives:
The student will be able to:
1. describe characteristics of a Reverse Split 'U'.
2. recognize and state the similarities and differences among 'U' Shapes, Split 'U's and Reverse Split 'U's.
3. label a given drawing "Reverse Split 'U'".
4. use ruler or measuring device to mark reference points and lines.
5. given examples, distinguish between correctly and incorrectly produced Reverse Split 'U' Shapes.
6. complete all necessary worksheets.
7. use developed rules to draw a conventional Kwagiulth Reverse Split 'U'.
8. use the term "Reverse Split 'U'" when speaking of this concept.
* 9. transfer completed design onto cardboard (Bristol Board), ready for painting.
*10. use developed techniques to paint her Reverse Split 'U'.
*11. paint secondary unit red and the formline black. (remember red and black have a dividing space)
*12. put title on concept, name, date on finished work and mount on coloured cardboard background.
*13. clean and store paint and brushes correctly.

*New Skills

CONCEPT #5
REVERSE SPLIT 'U'
(S.S.)

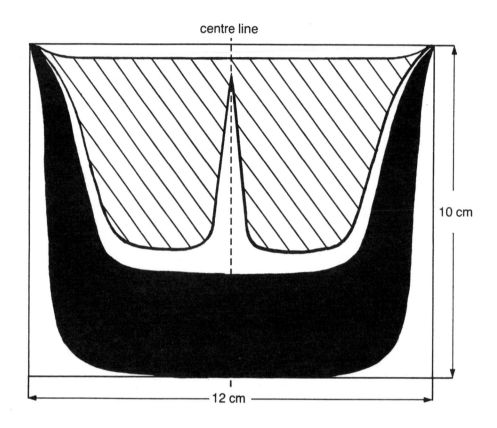

centre line

10 cm

12 cm

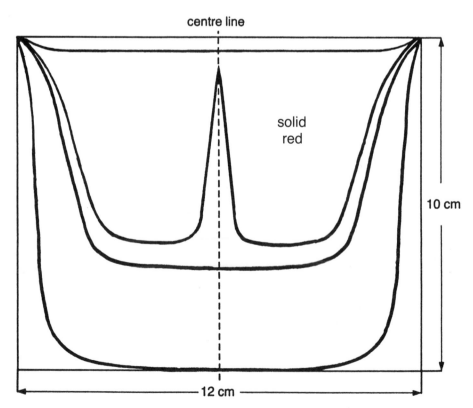

centre line

solid red

10 cm

12 cm

CONCEPT #5
REVERSE SPLIT 'U'
(S.S.)

Characteristics:
1. 'U' Shape.
2. Formline - black.
3. Reverse Split 'U' *(secondary filler unit).
4. Secondary Reverse Split 'U' cannot touch the black primary formline 'U' except at tapered ends.

Activities:
1. Complete worksheets a, b, c, d.
2. Draw a Reverse Split 'U' on a separate sheet of paper.
3. Transfer your drawing onto cardboard (Bristol Board).
4. Paint your Reverse Split 'U' according to the master example, using the techniques you have learned.
5. Clean your brushes and store them and the paint properly.
6. Explain how the three 'U' Shapes are alike and different.
7. Explain the difference between correctly and incorrectly produced Reverse Split 'U' Shapes.
8. On your finished painting, put the title "Reverse Split 'U'", your name and the date.
9. Mount your painting on coloured cardboard.

Materials:
 Pencil, paper, eraser, ruler, black water base paint, red paint, fine 02, 03 brushes, worksheets, master example sheets, plain Bristol Board, coloured Bristol Board.

REVERSE SPLIT 'U'
WORKSHEET "a"

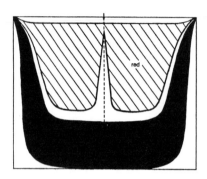

Connect the dots

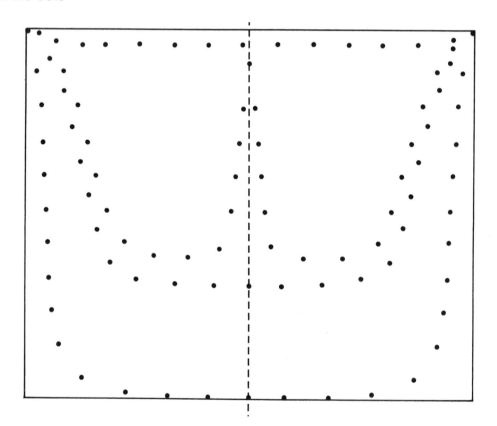

REVERSE SPLIT 'U'
WORKSHEET "b"

Fill in the missing lines.

Name: _____

REVERSE SPLIT 'U'
WORKSHEET "c"

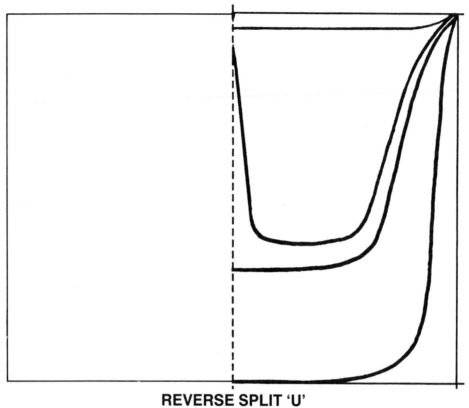

REVERSE SPLIT 'U'
WORKSHEET "d"

Measure and mark reference points.

10 cm

12 cm

Now make your own guidelines and reference points.

REVERSE SPLIT 'U'
WORKSHEET "e"

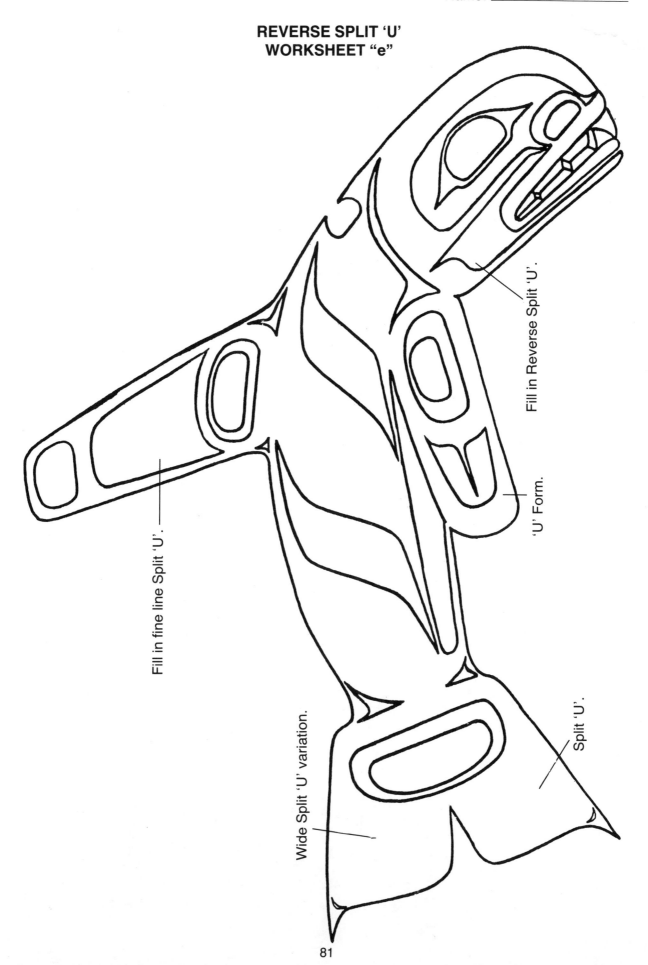

Fill in Reverse Split 'U'.

'U' Form.

Fill in fine line Split 'U'.

Split 'U'.

Wide Split 'U' variation.

WOLF
WORKSHEET "f"

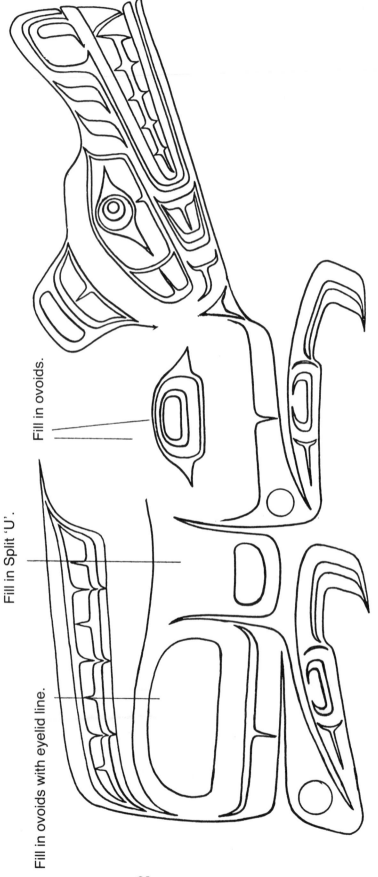

Fill in ovoids.

Fill in Split 'U'.

Fill in ovoids with eyelid line.

CONCEPT #6
VARIATIONS IN 'U' SHAPES
(T.S.)

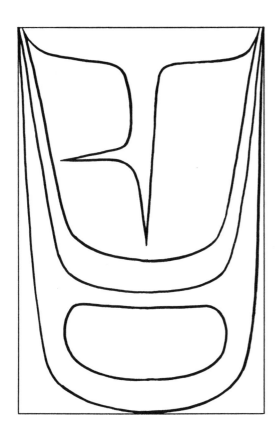 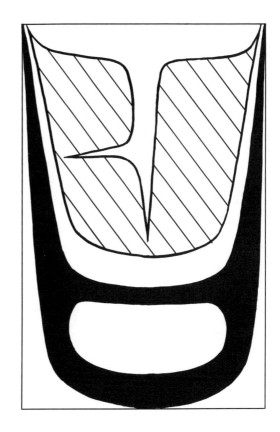

Characteristics:
1. Variations in length/width.
2. Variations in secondary filler units.

Objectives:

The student will be able to:
1. describe the characteristics of 'U' variations.
2. recognize and state the similarities and differences among 'U' Shapes, Split 'U's, Reverse Split 'U's and variations in 'U' Shapes.
3. label a given drawing "Variations in 'U' Shape".
4. use ruler or measuring device to mark reference points and lines.
5. complete all necessary worksheets.
6. use developed rules to draw two variations of Split 'U's, one with horizontal and one with vertical emphasis.
7. use the term "Variations in 'U' Shape" when speaking of this concept.
8. transfer completed design onto cardboard ready for painting.
9. use developed techniques to paint his variations.
10. paint secondary filler units red and the formline black (remember red and black have a dividing space).
11. clean and store material.
12. put the title, name, and date on finished work and mount it on coloured cardboard.

CONCEPT #6
VARIATIONS IN 'U' SHAPES
(S.S.)

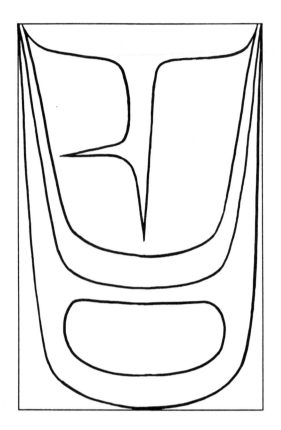

Materials:

 Pencil, paper, eraser, ruler,
black and red paint, fine brushes,
plain and coloured Bristol Board,
worksheets and two master example
sheets.

Characteristics:

 1. Variations in length/width.
 2. Variations in secondary filler units.

Activities:

 1. Complete worksheets a, b, c.
 2. Transfer your final drawing onto cardboard (Bristol Board).
 3. Paint your 'U' variation according to the master example.
 4. Complete worksheets d, e, f.
 5. Transfer your final drawing onto cardboard (Bristol Board).
 6. Paint your second 'U' variation according to the master example.
 7. Clean your brushes and store them and the paint properly.
 8. Explain how all the 'U' Shapes are alike and how they are different.
 9. On the finished paintings, put your name, the title, and the date.
10. Mount your finished work on coloured cardboard (Bristol Board).

VARIATIONS IN 'U' SHAPES
WORKSHEET "a"

VARIATIONS IN 'U' SHAPES
WORKSHEET "b"

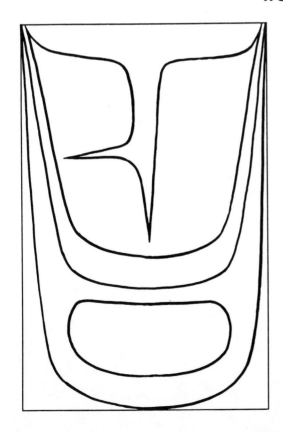

VARIATIONS IN 'U' SHAPES
WORKSHEET "c"

Measure and mark reference points.

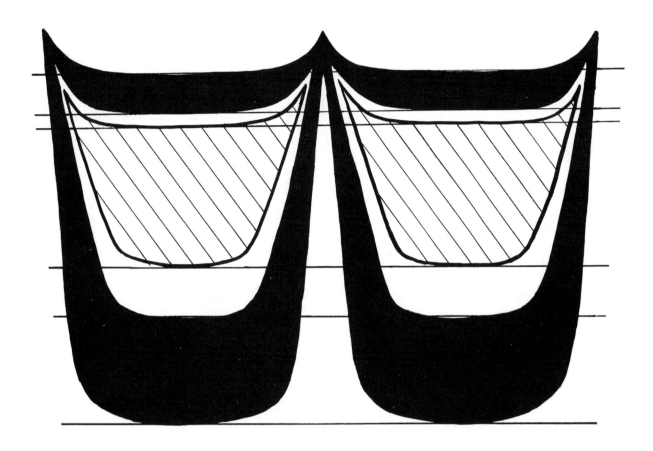

Characteristics: (see page 83)

Objectives: (see page 83)

VARIATIONS IN 'U' SHAPES
WORKSHEET "d"

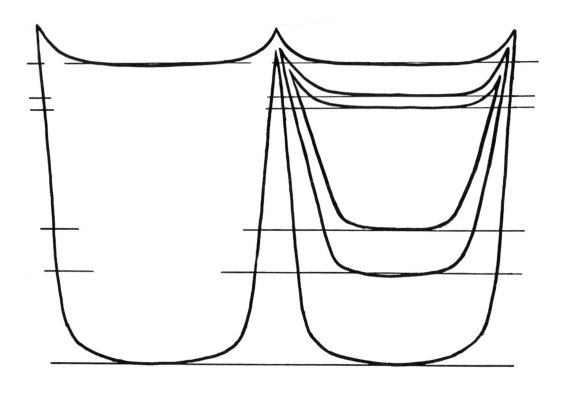

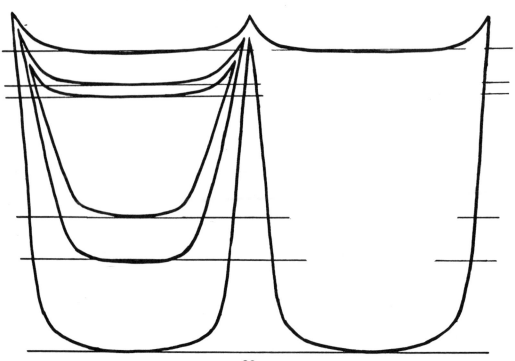

VARIATIONS IN 'U' SHAPES
WORKSHEET "e"

Measure and mark reference points.

Now make your own guidelines and reference points.

**THUNDERBIRD
WORKSHEET "f"**

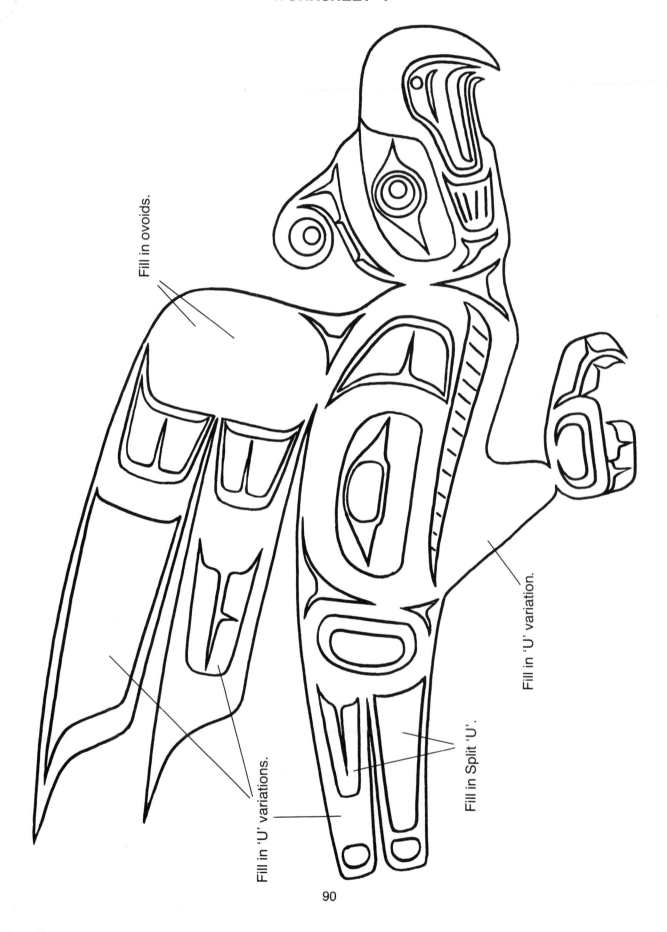

Fill in ovoids.

Fill in 'U' variation.

Fill in 'U' variations.

Fill in Split 'U'.

WOLF
WORKSHEET "g"

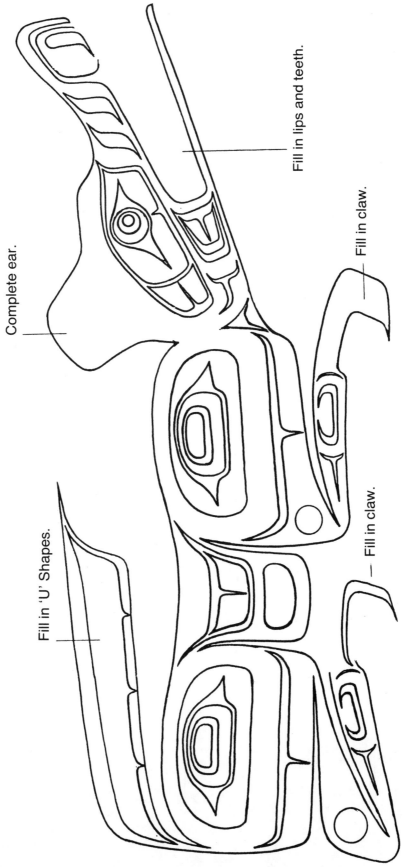

Fill in lips and teeth.

Fill in claw.

Complete ear.

Fill in claw.

Fill in 'U' Shapes.

VARIATIONS IN 'U' SHAPES

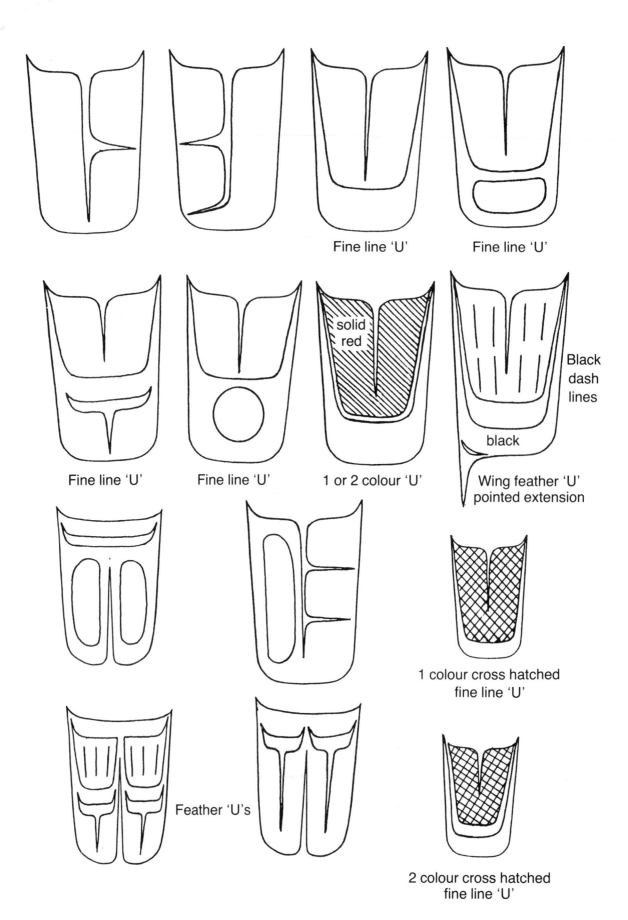

Fine line 'U'

Fine line 'U'

Fine line 'U'

Fine line 'U'

1 or 2 colour 'U'

solid red

Black dash lines

black

Wing feather 'U' pointed extension

1 colour cross hatched fine line 'U'

Feather 'U's

2 colour cross hatched fine line 'U'

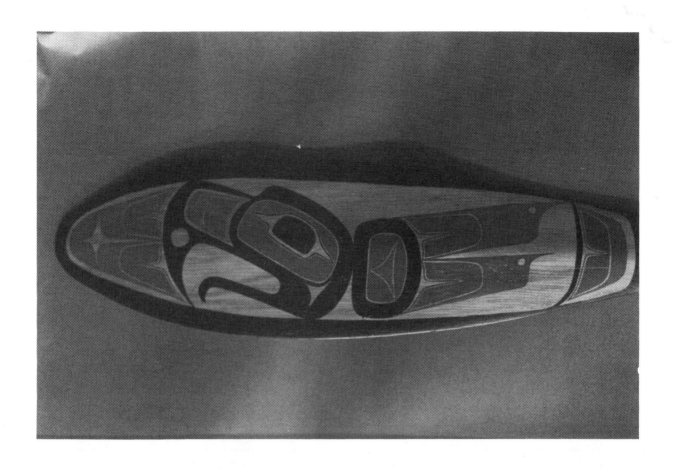

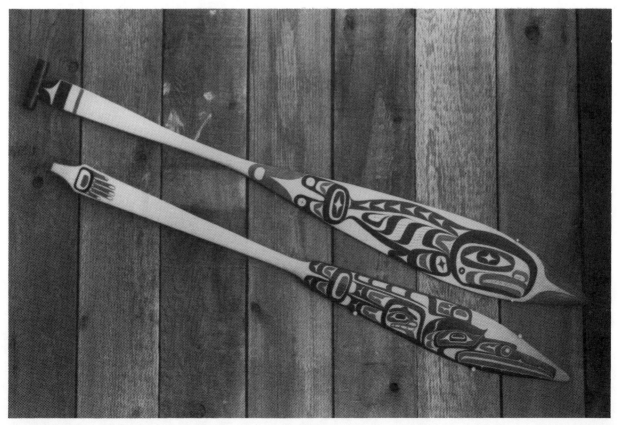

CONCEPT #7
'S' SHAPE BOX END DESIGN
(T.S.)

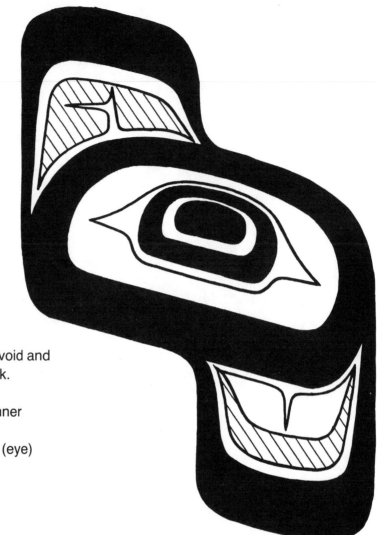

Characteristics:
1. Combination of primary ovoid and primary 'U' Shapes - black.
2. Unified design.
3. Variations in secondary inner filler units (a) 'U' Shapes
 (b) Inner Ovoid (eye)
4. Primary colour - black.
 Secondary colour - red.
5. Two colours in a design.

Objectives:
The student will be able to:
1. recognize and describe an 'S' Shape box end design.
2. state the characteristics of an 'S' Shape box end design.
3. use ruler or straight edge to mark reference points and lines.
4. complete all necessary worksheets.
5. use developed rules to draw an 'S' Shape box end design.
6. shown a decorated bent-wood box, distinguish between the main design and the end design.
7. use the term "box end design" when referring to this concept (recognize the 'S' Shape).
8. transfer completed design onto cardboard or prepared painting board.
9. paint her design.
10. paint secondary filler unit red, formlines black, variations in ovoid in the eye black (*recognize the spaces as well as the lines).
11. put title, name and date on finished work and mount on coloured cardboard.

CONCEPT #7
'S' SHAPE BOX END DESIGN

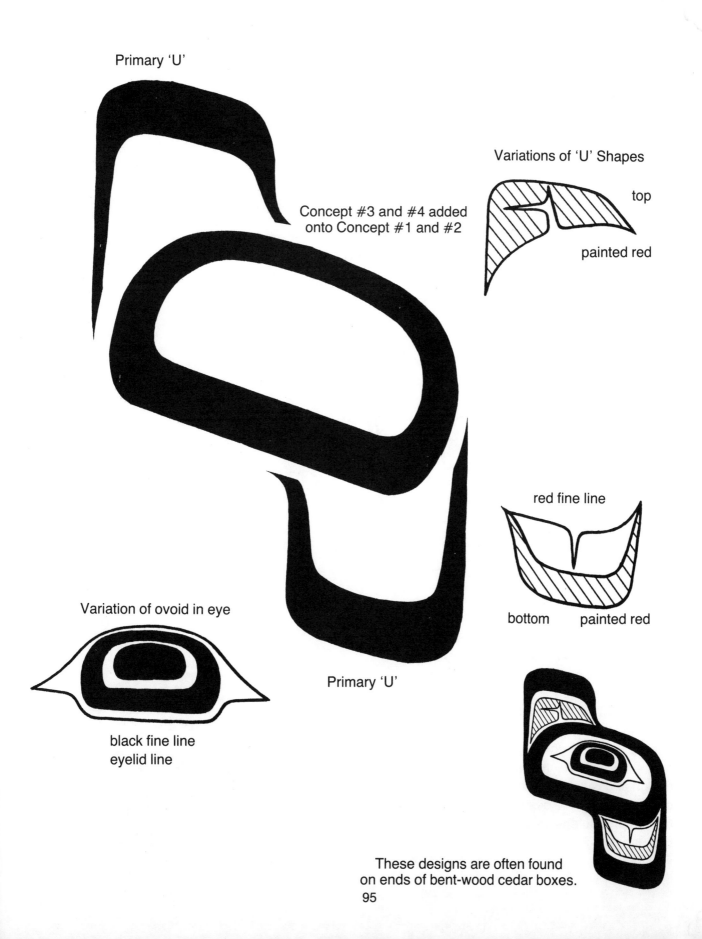

Primary 'U'

Concept #3 and #4 added
onto Concept #1 and #2

Variations of 'U' Shapes

top

painted red

red fine line

bottom painted red

Variation of ovoid in eye

black fine line
eyelid line

Primary 'U'

These designs are often found
on ends of bent-wood cedar boxes.

95

CONCEPT #7
'S' SHAPE BOX END DESIGN
(S.S.)

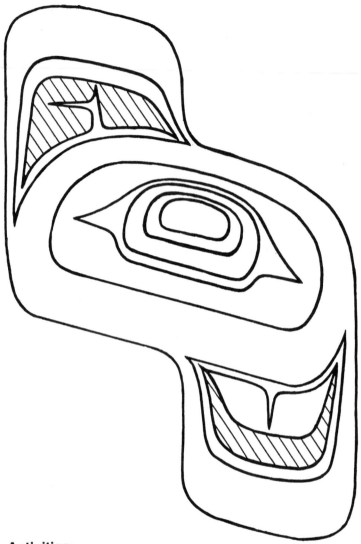

Characteristics:
1. Combination of primary ovoid and primary 'U' Shapes - black.
2. Unified design.
3. Variations in secondary inner filler units (a) 'U' Shapes
 (b) Inner Ovoid
4. Primary colour - black. Secondary colour - red.
5. Two colours in a design.

Materials:
Pencil, paper, eraser, ruler, black and red paint, plain and coloured Bristol Board, worksheets, and master example sheets.

Activities:
1. Complete worksheets a, b, c.
2. Transfer your final drawing onto cardboard.
3. Paint your box end design according to the master sample sheet.
4. Clean your brushes and store them and the paint properly.
5. In a picture of a bentwood box, show which is the main design and which is the box end design. Explain the difference.
6. List the characteristics of an 'S' Shape box end design.
7. Put your name, date and title on your finished painting.
8. Mount your work on coloured cardboard.

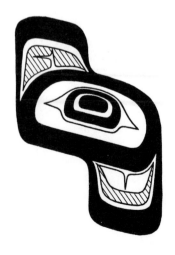

'S' SHAPE BOX END DESIGN
WORKSHEET "a"

Fill in the variations in secondary inner filler ovoids
(Ovoid and 'U' Shapes).

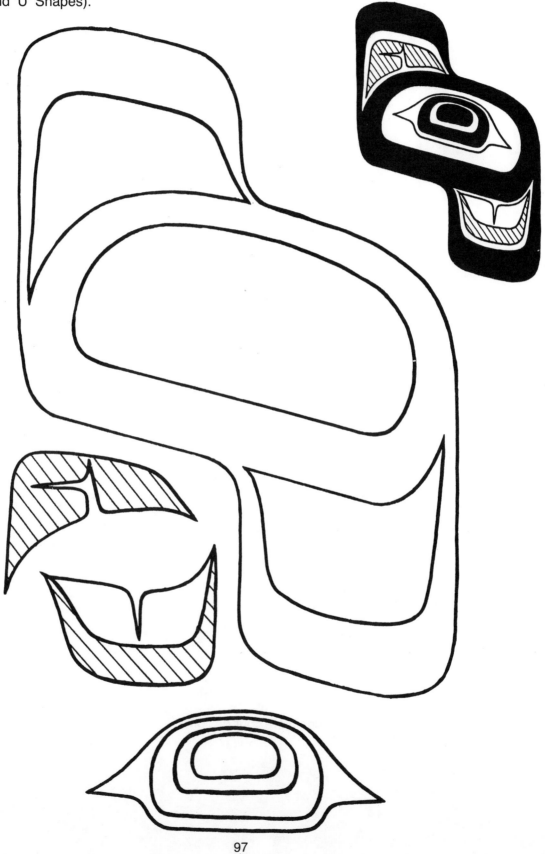

'S' SHAPE BOX END DESIGN
WORKSHEET "b"

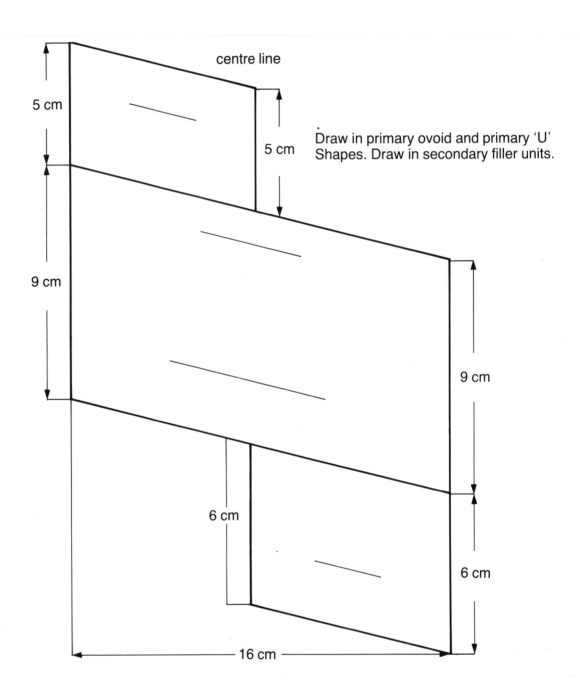

centre line

5 cm

5 cm

Draw in primary ovoid and primary 'U' Shapes. Draw in secondary filler units.

9 cm

9 cm

6 cm

6 cm

16 cm

Now draw your own guidelines and complete your design.

CONCEPT #8
SALMON-TROUT HEAD
(T.S.)

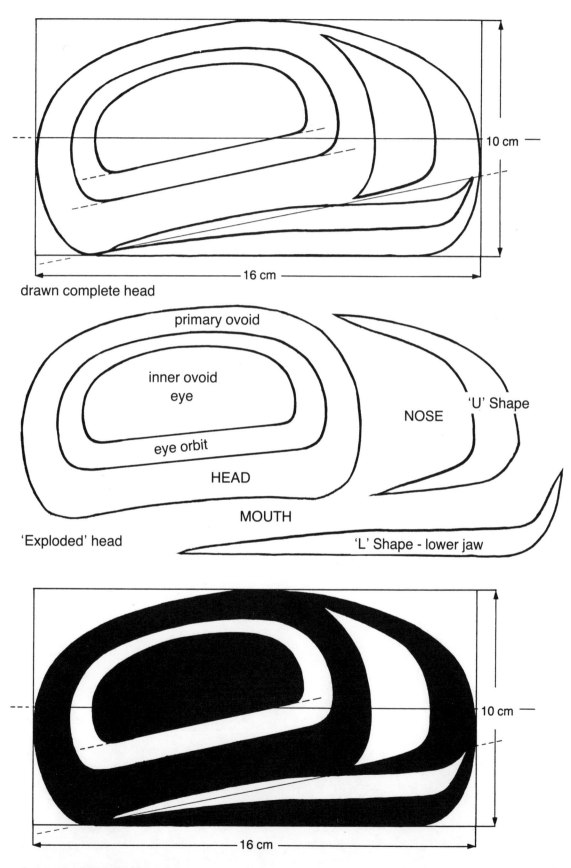

drawn complete head

10 cm

16 cm

primary ovoid

inner ovoid
eye

eye orbit

HEAD

MOUTH

NOSE

'U' Shape

'L' Shape - lower jaw

'Exploded' head

drawn and painted head

10 cm

16 cm

CONCEPT #8
SALMON-TROUT HEAD
(T.S.)

Characteristics:
1. Ovoid Shape.
2. 'U' Shape.
3. 'L' Shape.
4. Relieving circle.
5. Mouth.

Objectives:
The student will be able to:
1. state the characteristics of a salmon-trout head.
2. recognize and describe a salmon-trout head.
3. use ruler or straight edge to mark reference points and lines.
4. complete worksheets.
5. use established rules to draw salmon-trout head.
6. use the term "salmon-trout head" when referring to this concept.
*7. choose and prepare wood for transfer of design (sanding, rasping).
*8. transfer design onto cedar wood plaque.
*9. paint her design with appropriate water-based wood paint.
10. put title, name and date on finished work.
*11. oil finished work with wood oil to protect the surface.
*12. shown a design which includes a salmon-trout head, identify it.

*New Skills.

CONCEPT #8
SALMON-TROUT HEAD
(S.S.) #1

Characteristics:
1. Ovoid Shape.
2. 'U' Shape.
3. 'L' Shape.
4. Relieving circle.
5. Mouth.

Activities:
1. Complete simplified salmon-trout head on student sheet #2.
2. Colour this drawing according to the master example.
3. Complete complex salmon-trout head using previous measuring and drawing techniques (use a circle template).
4. Prepare wood surface by sanding and/or rasping all surfaces. Finish the painting surface with fine grit sand paper and wipe with a paper towel.
5. Transfer your drawing onto the wood taking care to use the **side** of your pencil.
6. Paint your salmon-trout head according to the master example sheet.
7. Put title, name, and date on the plaque.
8. Clean your brushes and store them and the paint properly.
9. After the paint has dried for several days, oil the surface and sides of your plaque.
10. Put a hanger on the back.
11. Describe a salmon-trout head.
12. In a large design, identify a salmon-trout head.

Materials:

Paper, pencil, eraser, ruler, black and red water-based wood paint, fine brushes, rectangular cedar wood approximately 1" x 12" x ? (get irregular shapes — whatever scraps will suit for a plaque), worksheets, master example sheets, sand paper (different grits), rasp, wood oil, circle template.

CONCEPT #8
SALMON-TROUT HEAD
(S.S.) #2

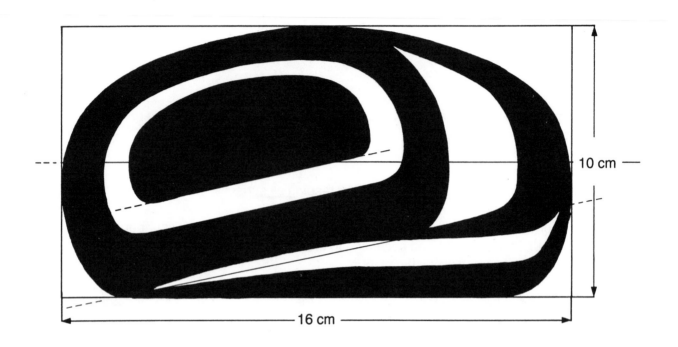

10 cm

16 cm

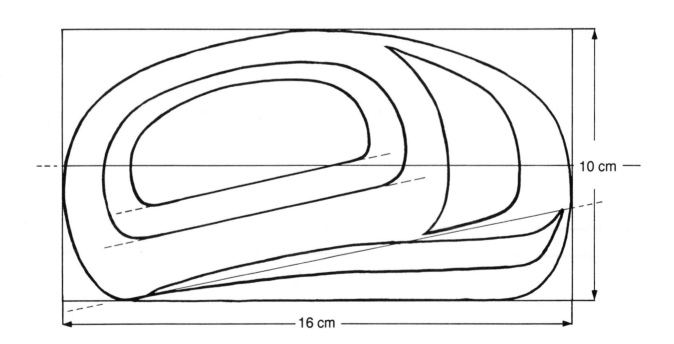

10 cm

16 cm

SALMON-TROUT HEAD
WORKSHEET "a"

centre line

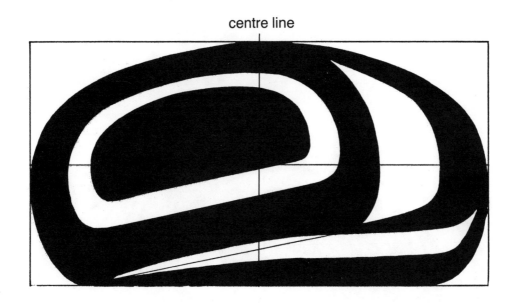

Complete design below.

Name: _____

SALMON-TROUT HEAD
WORKSHEET "b"

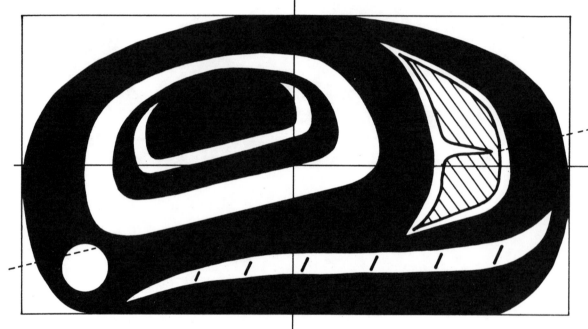

Draw the above design in the box below.

centre line

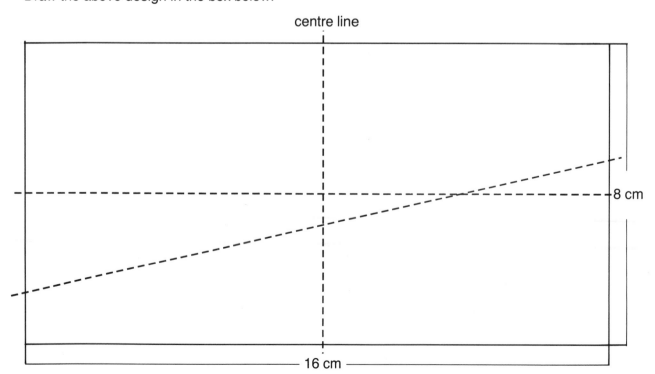

8 cm

16 cm

THUNDERBIRD
WORKSHEET "c"

Fill in Salmon-Trout Head.

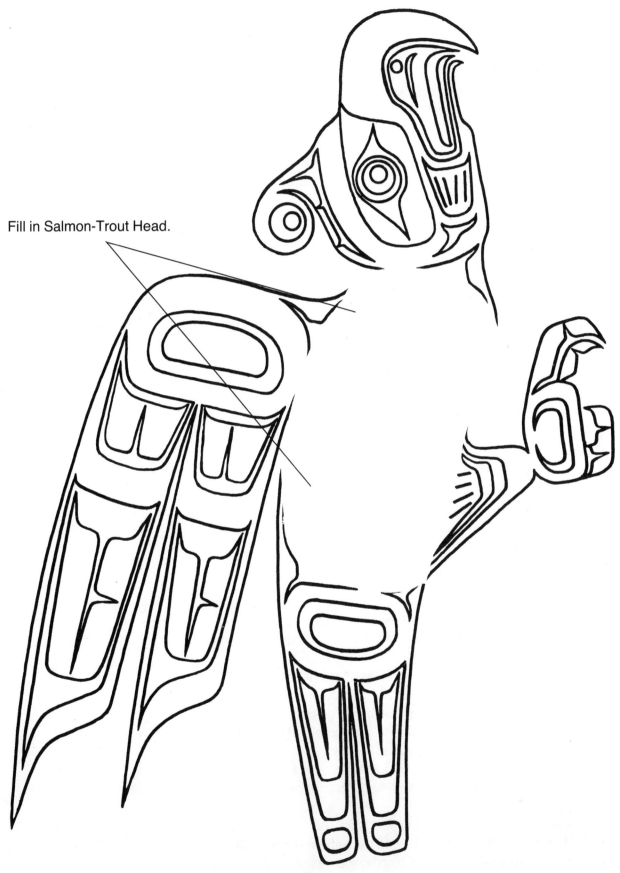

CONCEPT #9
KILLER WHALE HEAD

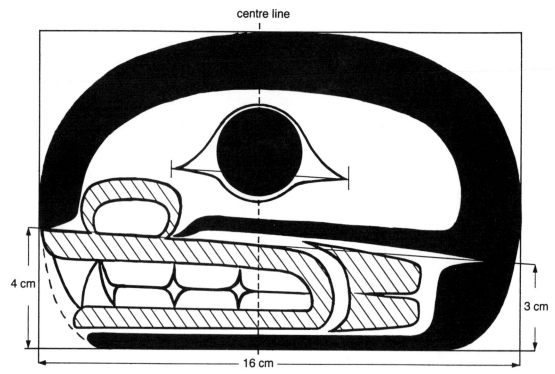

centre line

4 cm

3 cm

16 cm

Characteristics:
1. Whale Head inside basic ovoid shape.
2. Two colour design - red and black.
3. Eye (circle) with eyelid line - use plastic template.
4. Eye orbit (may be painted green).
5. Nostril (ovoid) - red.
6. Lips ('U' Shape) - red.
7. Teeth (fine line) - black.
8. Reverse Split 'U' Shape (gill) - red secondary filler.

Objectives:
The student will be able to:
1. recognize and describe a killer whale head.
2. state the characteristics of a killer whale head.
3. complete a drawing of a killer whale head that has some lines missing.
4. complete worksheets.
5. use established rules to draw a killer whale head.
6. use the term "killer whale head" when referring to this concept.
7. choose and prepare wood for transfer of design.
*8. if necessary, enlarge his design to cover most of the wood surface.
9. transfer design onto wood plaque.
10. paint her design with appropriate water-based wood paint.
11. *may paint eye orbit green remembering to allow a small space between the green and any other colour.
12. put title, name and date on finished work.
13. oil finished work with wood oil and put hanger on the back.
14. identify a killer whale head in a complete design.

KILLER WHALE HEAD

Steps to Follow:

1. Draw a reference rectangle
 16 cm x 20 cm on white paper
 with centre line at 10 cm.
2. Draw outside ovoid line.
3. Draw an oblique guideline through
 dotted centre line as a guide for
 drawing the top lip line.
4. Draw inside ovoid line to form eye
 orbit.

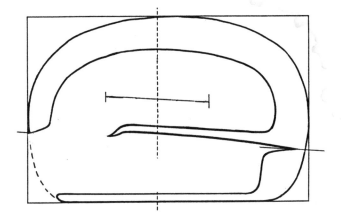

5. Draw mouth - outside nostril and lip lines
 - inside nostril and lip lines.
6. Draw teeth, reverse split 'U' (gill)
 secondary filler.

7. Draw eye (centre on centre line of rectangle)
 - use circle template
 - bottom of eyelid line is straight

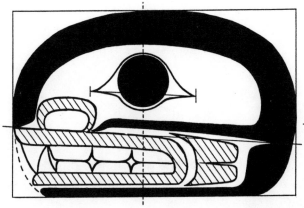
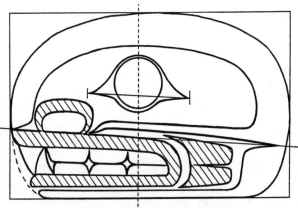

CONCEPT #9
KILLER WHALE HEAD
(S.S.)

centre line

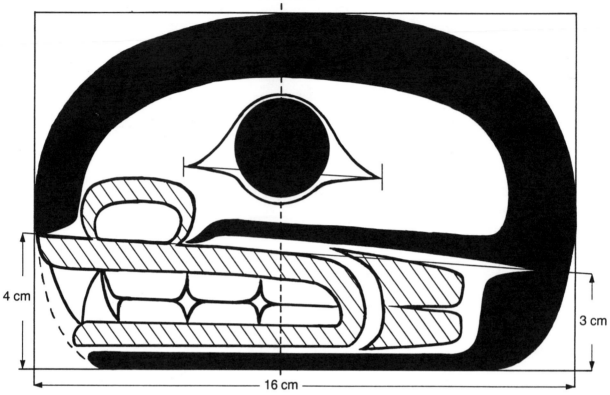

Characteristics:
1. Whale head inside basic ovoid shape.
2. Two colour design - red and black.
3. Eye (circle) with eyelid line - use plastic template.
4. Eye orbit (may be painted green).
5. Nostril (ovoid) - red.
6. Lips ('U' Shape) - red.
7. Teeth (fine line) - black.
8. 'U' Shape (gill) - red secondary filler.

Activities:
1. Complete worksheets a, b, c.
2. See steps to follow page 107.
3. Follow steps #4 to #10 on Salmon-Trout Head sheet (if necessary, enlarge design to fit the wood).
4. Describe a whale head.
5. State the characteristics of the whale head.
6. In a large design, identify the whale head.

Materials:
Pencil, paper, eraser, ruler, water-based wood paint (black, red, and green), fine brushes, rectangular cedar wood plaques, rasp, sand paper, wood oil, worksheets, master example sheets and circle template.

KILLER WHALE HEAD
WORKSHEET "a"

Draw in the eyelid line and the eye orbit.

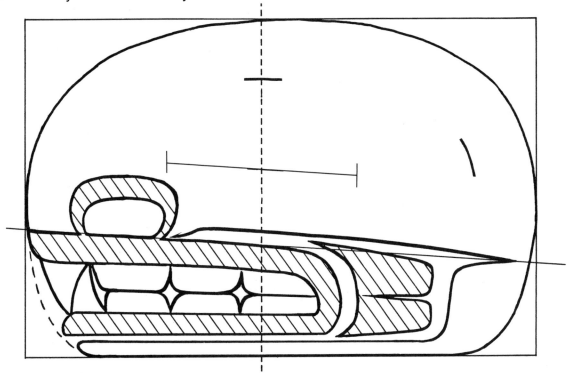

KILLER WHALE HEAD
WORKSHEET "b"

Draw in the lips, mouth, teeth, nostril and gill (Reverse Split 'U').

centre line

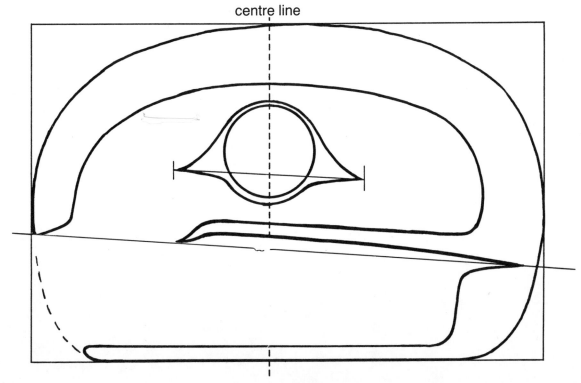

KILLER WHALE HEAD
WORKSHEET "c"

Draw a complete killer whale head.

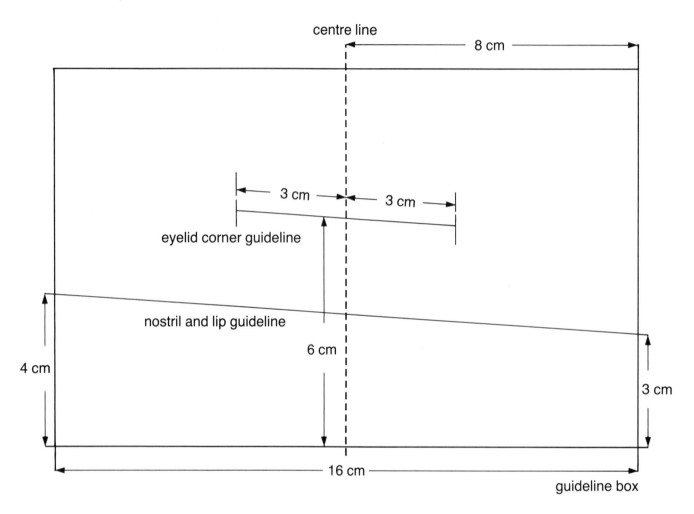

centre line

8 cm

3 cm 3 cm

eyelid corner guideline

nostril and lip guideline

6 cm

4 cm

3 cm

16 cm

guideline box

Name: _____

KILLER WHALE
WORKSHEET "d"

Fill in Killer Whale Head.

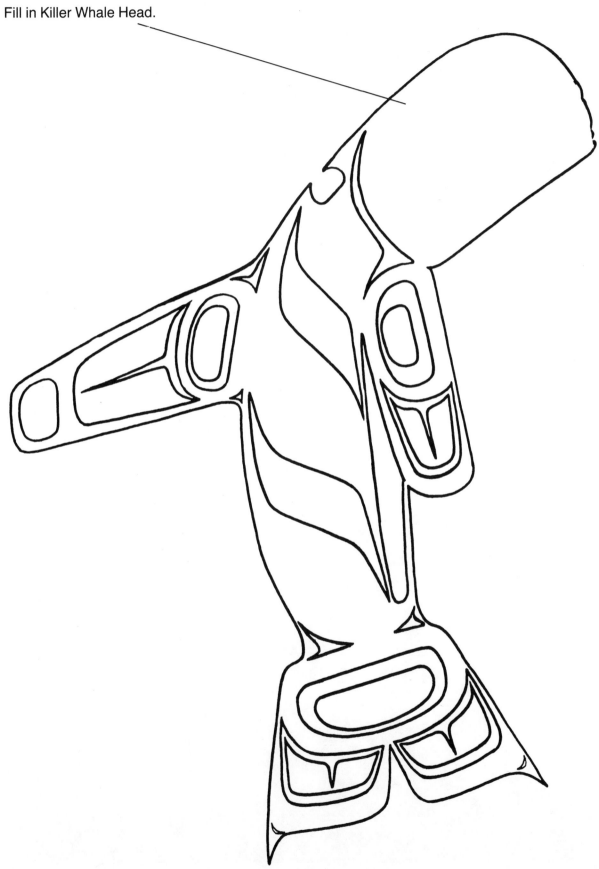

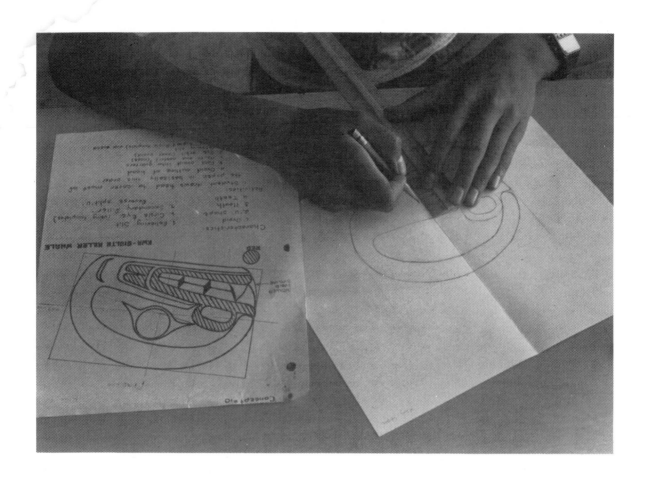

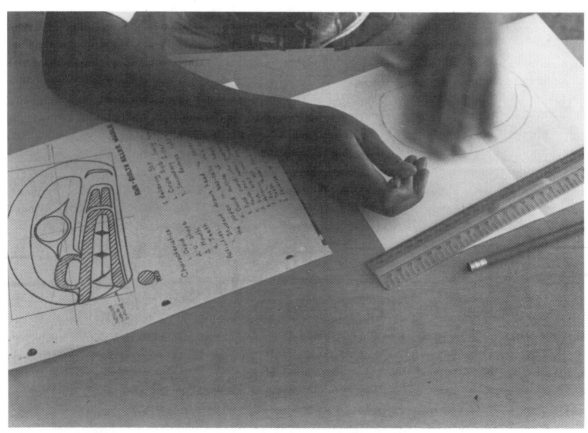

PAINTING A KILLER WHALE HEAD

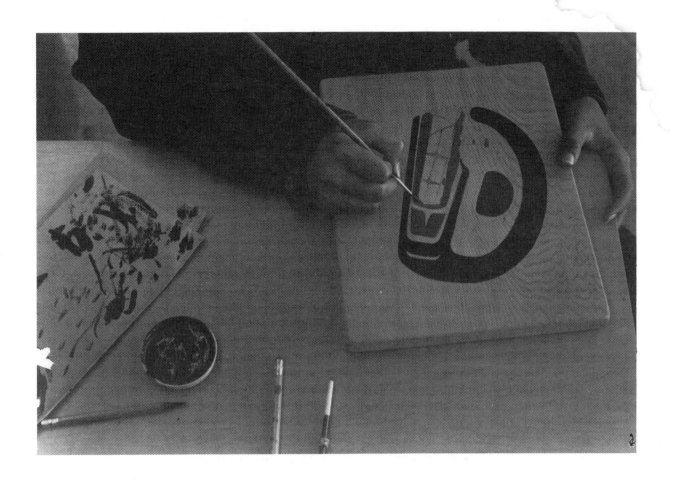

TRANSFERRING FROM PAPER TO WOOD

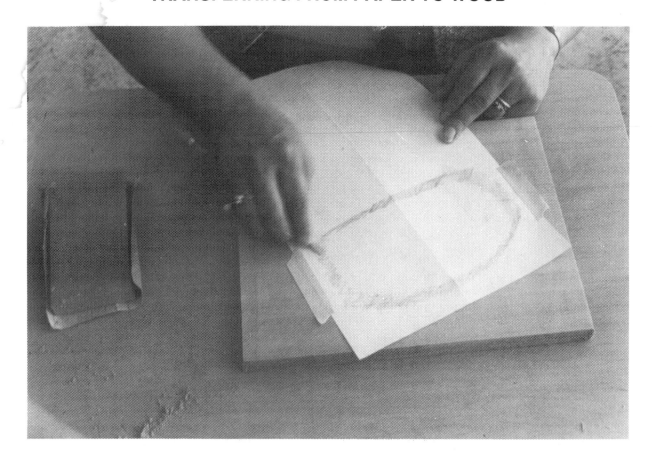

PREPARING BOARD FOR TRANSFER

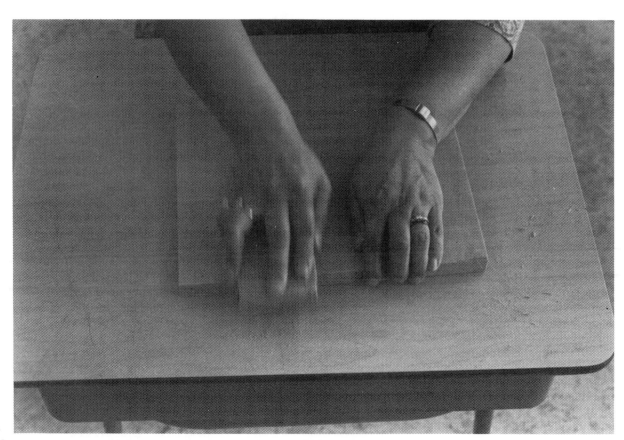

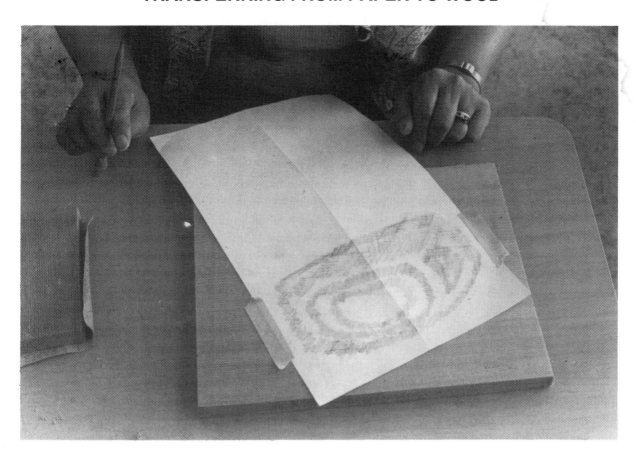

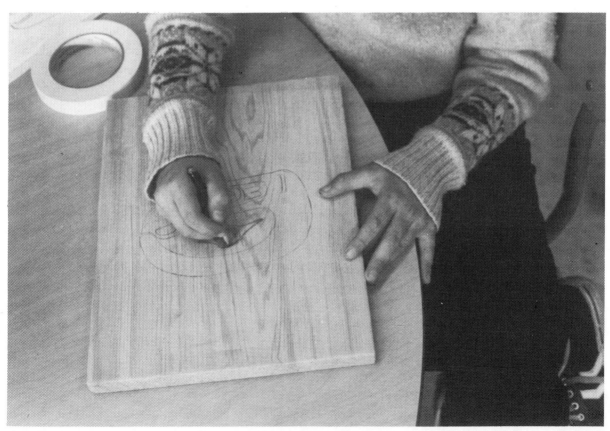

CONCEPT #10
EAGLE HEAD
(T.S.)

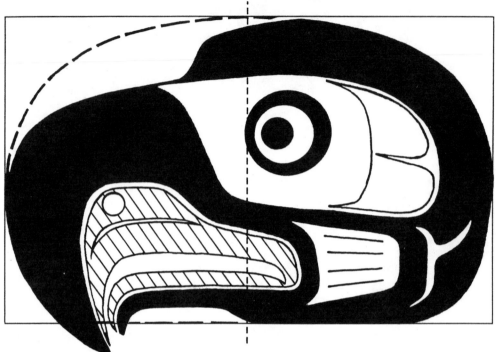

Characteristics:
1. Light pencil ovoid guideline and centre fold lines.
2. Head and beak outline.
3. Inside - beak, nostril and lipline.
4. Eye orbit.
5. Cheek 'U'.
6. Relieving slit.
7. Eye - eyeball with pupil and eyeball outline (no eyelid line).
8. Split 'U'.

Objectives:

The student will be able to:
1. recognize and describe a Kwagiulth eagle head.
2. state the characteristics of an eagle head.
3. compare and contrast a Kwagiulth eagle head with a Kwagiulth killer whale head.
4. compare this stylized representation with the bird in nature.
5. complete worksheets.
6. use established rules to draw an eagle head.
7. use the term "eagle head" when referring to this concept.
8. choose and prepare wood or prepared painting surface.
9. if necessary, enlarge the design to fit the surface.
10. transfer the design onto the prepared surface.
11. paint her design with appropriate paint.
12. may paint eye orbit yellow remembering to allow a small space between the yellow and other colours.
13. put title, name and date on finished work.
14. oil finished work with wood oil and put a hanger on the back.

CONCEPT #10
EAGLE HEAD
(S.S.)

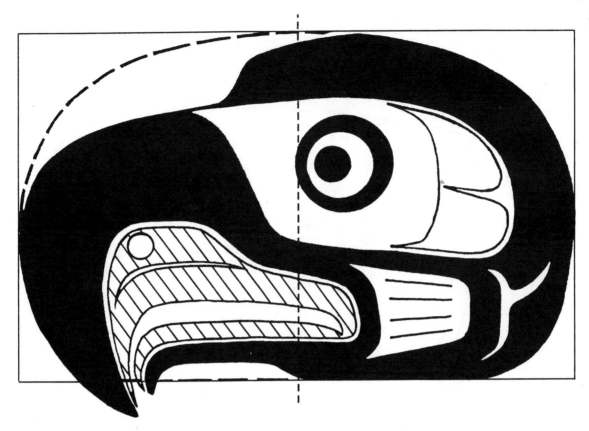

Characteristics:
1. Light pencil ovoid guideline and centre fold line.
2. Head and beak outline.
3. Inside - beak, nostril and lipline.
4. Eye orbit.
5. Cheek 'U'.
6. Relieving slit.
7. Eye - eyeball with pupil and eyeball outline (no eyelid line)
8. Split 'U'.

Activities:
1. Complete worksheets a, b, c.
2. Draw the eagle head in the order the characteristics are written.
3. Follow steps #4 to #10 on Salmon-Trout Head sheet page 101 (if necessary enlarge the design to fit the wood).
4. Describe an eagle head.
5. State the characteristics of an eagle head.
6. In a large design, identify the whale head.

Materials:
Pencil, paper, eraser, ruler, water-based wood paint (black, red and yellow), fine brushes, rectangular cedar wood plaques, rasp, sand paper, wood oil, worksheets, master example sheet, and circle template.

CONCEPT #10
EAGLE HEAD
(S.S.)

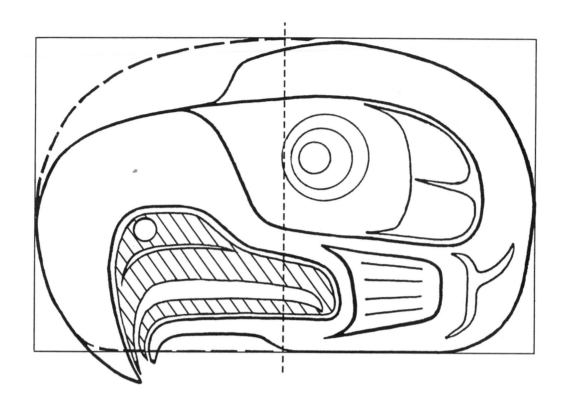

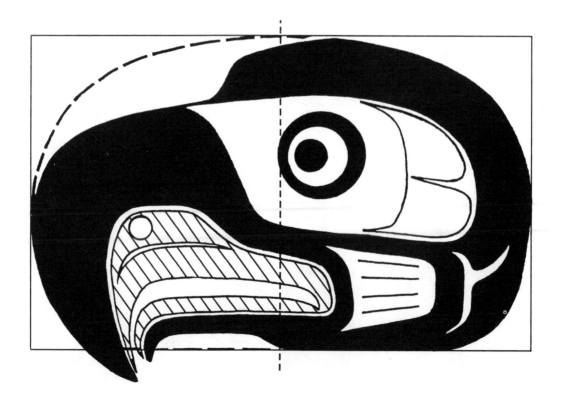

EAGLE HEAD
WORKSHEET "a"

Draw in the cheek, beak, nostril and lip.

centre line

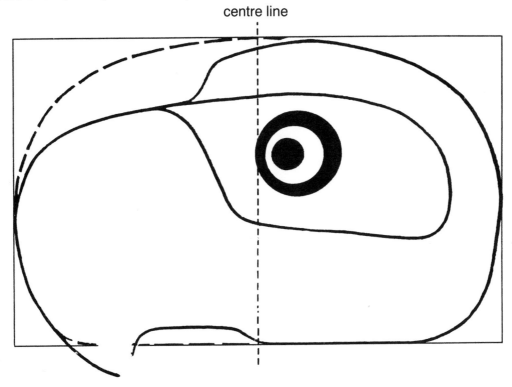

Draw in the eye and and the eye orbit.

centre line

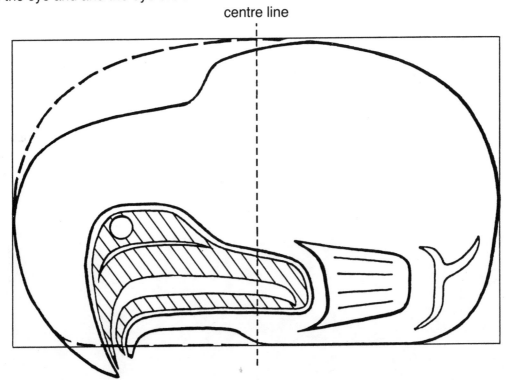

EAGLE HEAD
WORKSHEET "b"

Draw complete eagle head.

THUNDERBIRD
WORKSHEET "c"

Fill in eagle head.

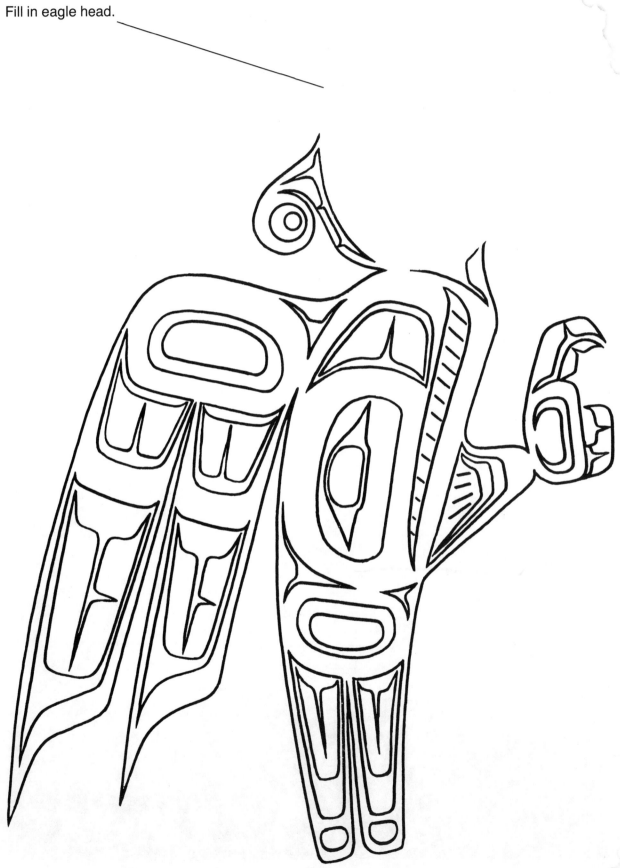

PAINTING AN EAGLE HEAD

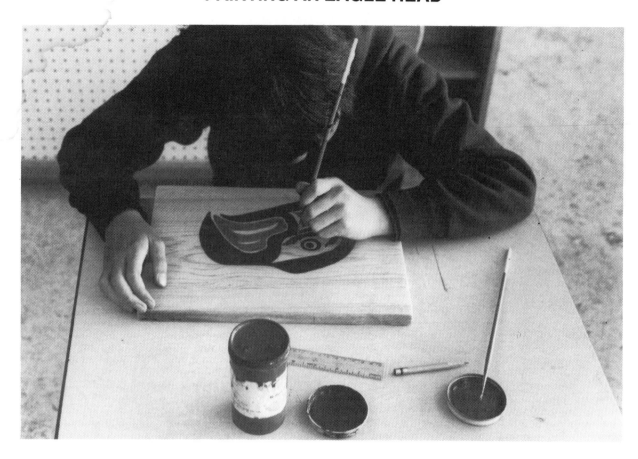

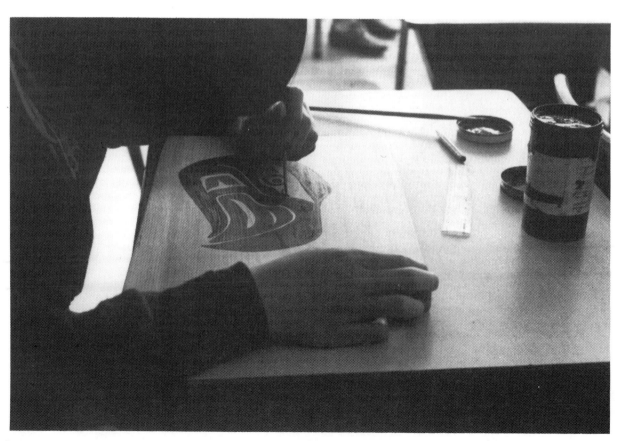

CONCEPT #11
KNIFE HANDLES
(T.S.)

Objectives:

The student will be able to:

1. mark both ends of the rectangular "blank" of wood as a guide for finished grip size.
2. carve "blank" into an oval or cylindrical shape, the right size for his/her hand.
3. use appropriate carving techniques to carve the handle.
4. place a knife blade in the slot after it has been cut in the centre of the smaller end of the handle with a saw.
5. place and fix a blade as per instructions.
6. maintain and sharpen his/her knives.

Materials:

Yellow cedar knife handle "blank", knife blades (straight, curved and full-curved), wrapping string, wood and epoxy glue, masking tape, carving knives (ready to use, straight blade knives).

Activities:

1. Discuss carving techniques and traditional carving tools.
2. Discuss the three kinds of knife blades.
3. Discuss safe handling of equipment.
4. Demonstrate correct grip, angle and direction of carving.
5. Demonstrate the carving of a knife handle from beginning to end (see pages 124, 125).
6. Using a saw, cut slots in the narrow end of the carved handles.
7. Demonstrate mounting of the blade in the handle (see page 124).
*8. Blade edges should **always** be covered with masking tape when mounting in handle and when not in use.
9. Permit students to attempt carving the knife handles and mounting the blades under strict supervision.

CONCEPT #11
KNIFE HANDLES
(T.S.)

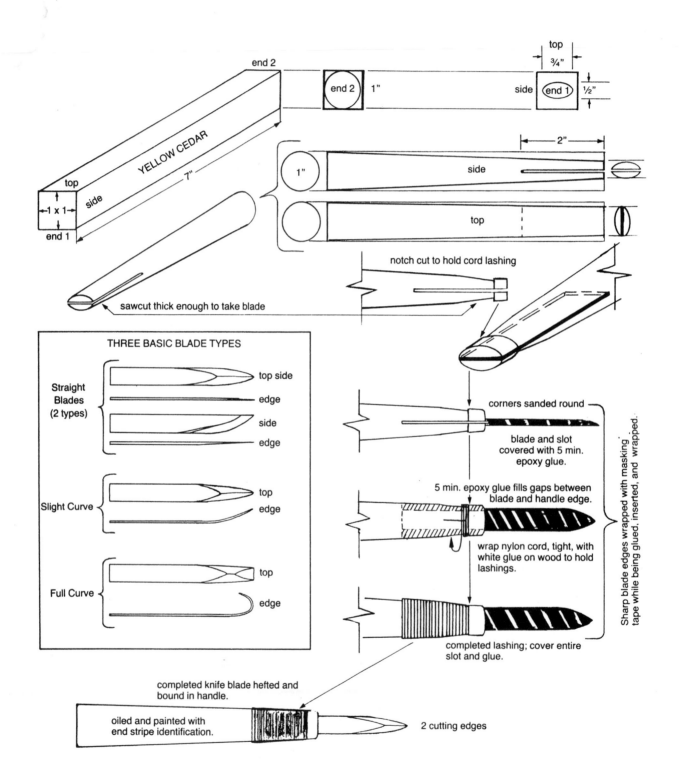

THREE BASIC BLADE TYPES

Straight Blades (2 types)
- top side
- edge
- side
- edge

Slight Curve
- top
- edge

Full Curve
- top
- edge

end 2

top ¾"

end 2 1"

side end 1 ½"

YELLOW CEDAR

7"

top

side

1 x 1

end 1

2"

side

top

1"

notch cut to hold cord lashing

sawcut thick enough to take blade

corners sanded round

blade and slot covered with 5 min. epoxy glue.

5 min. epoxy glue fills gaps between blade and handle edge.

wrap nylon cord, tight, with white glue on wood to hold lashings.

completed lashing; cover entire slot and glue.

Sharp blade edges wrapped with masking tape while being glued, inserted, and wrapped.

completed knife blade hefted and bound in handle.

oiled and painted with end stripe identification.

2 cutting edges

CARVING A KNIFE HANDLE

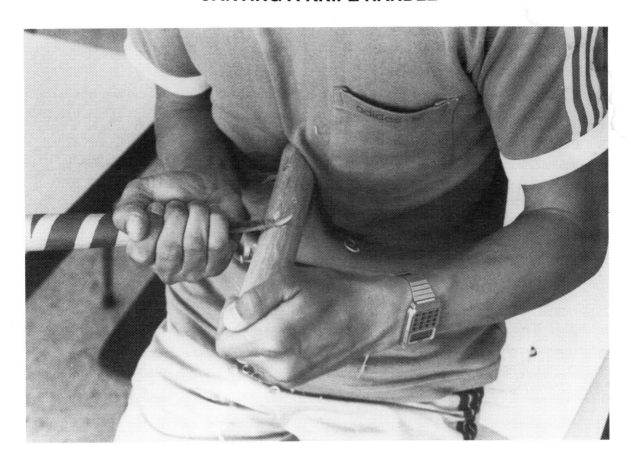

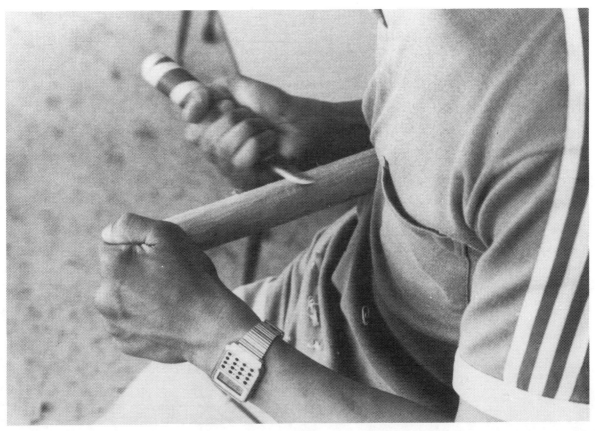

CONCEPT #12
BAS-RELIEF WHALE

Objectives:

Students will be able to:

1. draw a killer whale head the proper size for a chosen piece of wood (if there are time constraints, a student may re-use a previous drawing).
2. transfer the design to a prepared piece of wood.
3. draw a guideline to a depth of ⅜" (1 cm) along all four edges of the wood.
4. draw a "rough-out" line ⅛" (3 mm) - ¼" (6 mm) around the outside of the design to allow for carving errors.
5. carve, as per instructions, all wood outside the main design to a depth of ⅜" (1 cm).
6. sand finished carved area, check and repair transferred design.
7. paint the design.
8. put on title, name and date.
9. oil finished work and put a hanger on the back.

Materials:

Pencil, paper, eraser, ruler, water-based wood paint (black, red and green), fine brushes, rectangular cedar wood plaques, rasp, sand paper, wood oil, master example sheet, circle template, masking tape, carving knives (straight, curved, and full-curved blades), broom, dustpan, workmate bench.

FINISHING A BAS-RELIEF WHALE PLAQUE

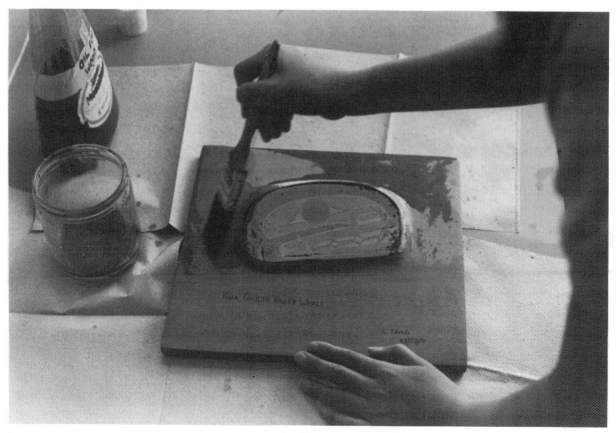

CONCEPT #13
BAS-RELIEF EAGLE
(Interior Areas Carved)

Objectives:

The student will be able to:
1. see objectives Concept #12.
2. carve, using all three types of blades, designated interior areas of design.

Materials:

Pencil, paper, eraser, ruler, water-based wood paint (black, red and yellow), fine brushes, rectangular cedar wood plaques, rasp, sand paper, wood oil, master example sheet, template, masking tape, carving knives (straight, curved and full-curved blades), broom, dustpan, workmate bench.

CARVING A BAS-RELIEF EAGLE

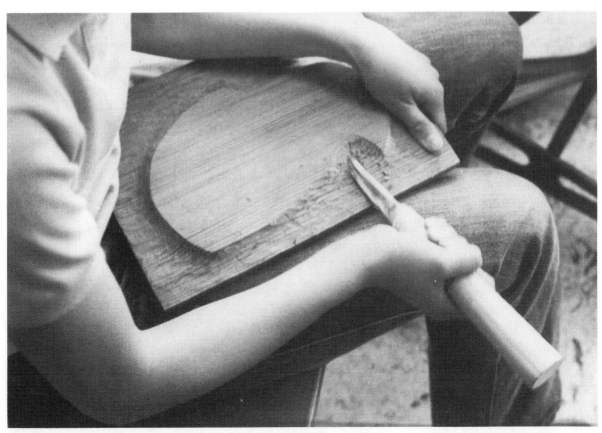

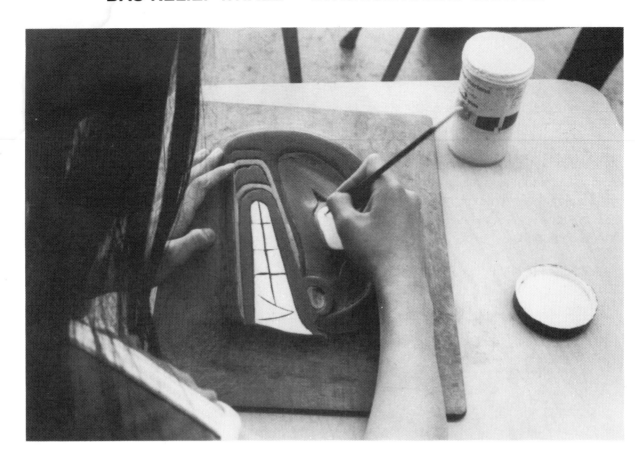

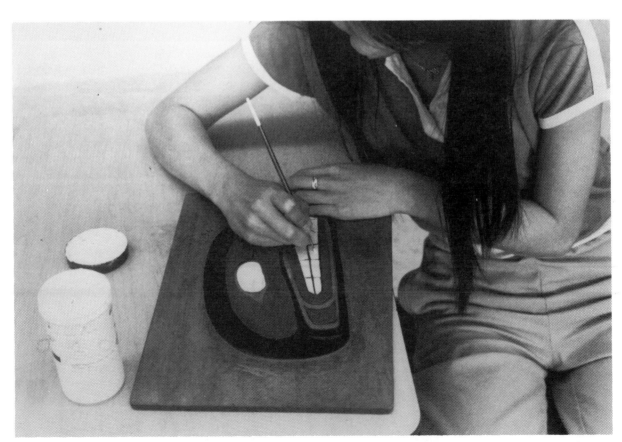

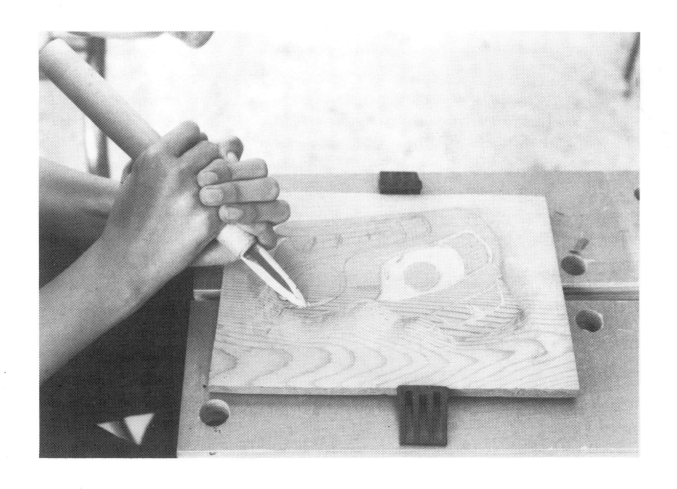

CONCEPT #14
CARVED SERVING TRAY

Objectives:

Student will be able to:

1. prepare a tray blank for carving.
2. carve out a complete border on the underside. (This serves as a hand grip.)
3. carve out the tray interior as per illustration sheet.
4. finish tray surface for painting.
5. draw and transfer a design onto a tray surface.
6. paint and finish the tray surface.

Materials:

 Tray blanks, carving knives, illustration sheet, drawing to transfer onto the serving surface, rasp, sand paper, masking tape, water-based wood paint and wood oil.

CARVING OUT A SERVING TRAY

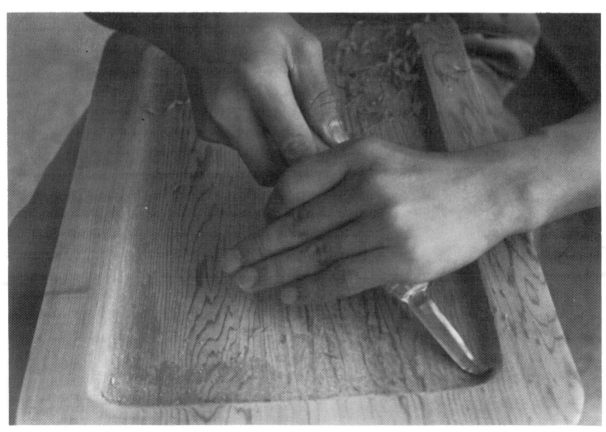

CONCEPT #14
CARVED AND PAINTED SERVING TRAY

CEDAR SERVING TRAY 11½" x 19"
Make tray blanks from S4S ¾" x 11½" knot-free, edge grain cedar.
Round off the four corners by cutting with a saw.

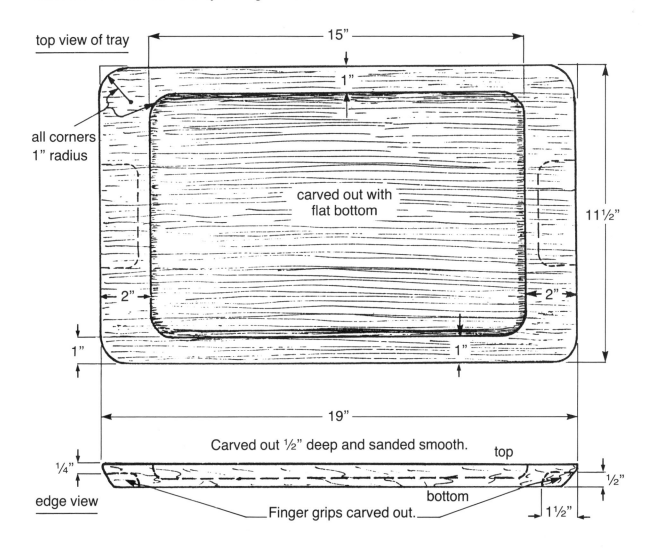

top view of tray

15"

1"

all corners
1" radius

carved out with
flat bottom

11½"

2" 2"

1" 1"

19"

Carved out ½" deep and sanded smooth. top

¼" ½"

edge view bottom

Finger grips carved out. 1½"

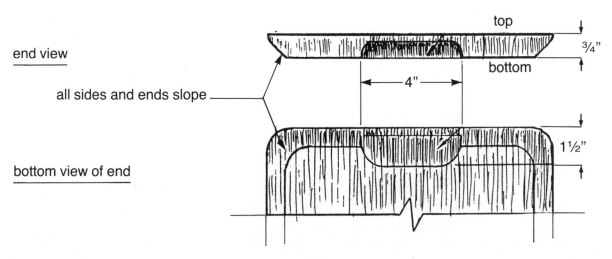

end view

all sides and ends slope

top ¾"

4" bottom

bottom view of end 1½"

131

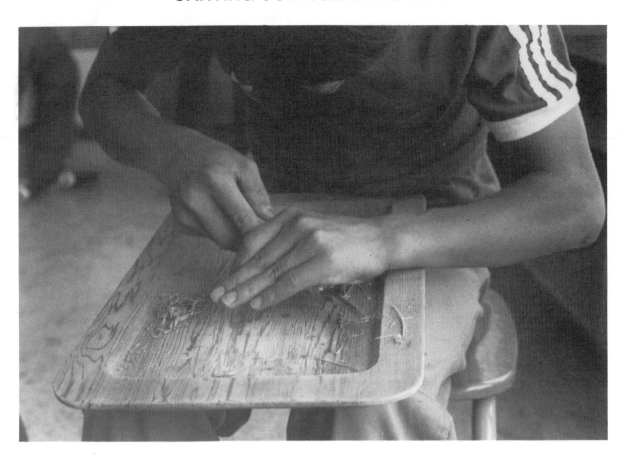

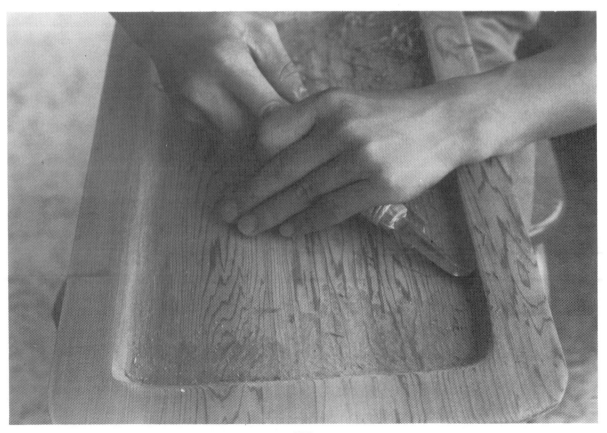

CONCEPT #15
CEREMONIAL PADDLE

Objectives:

The student will be able to:

1. carve a paddle from a paddle blank.
2. finish the surface for painting.
3. draw and transfer a major design onto one side of the paddle.
4. draw and transfer "filler" designs onto the other side of the paddle.
5. carve top handle and affix it to the paddle.
6. paint and finish the paddle surface.
7. compare the "blade" of a knife to the "blade" of a paddle.

Materials:

Paddle blanks, carving knives, 2 illustration sheets, 2 drawings to transfer onto the paddle surface, rasp, sand paper, masking tape, water-based wood paint and wood oil.

CONCEPT #15
CARVED CEREMONIAL PADDLE

STEP 1 — layout of paddle shape and transfer to wood.

Draw 1" squares 3" wide and 22" long on light cardboard. Number the squares as seen on the sheet and then draw the left half of the paddle outline. Carefully cut this out with scissors and lay the cardboard ½ paddle template on the wood with the drawn straight edge as the centre line. Use small pieces of masking tape to hold the cardboard onto the wood. Trace around the outline with a pencil. Remove the tape and do the same for the other side.

STEP 2

Cut it out with a sabre or bandsaw.

STEP 3

Draw centre lines on the ¾" sawed edges.

STEP 4

Starting from the centre line, gradually carve off more wood as you reach the outside edge of paddle to achieve a tapered effect. Round off all edges. Do NOT carve off the edge centre lines.

STEP 5

Carve round edges on the handle top and hand grip.

STEP 6

Before sanding with 100 grit sand paper, smooth the entire paddle surface with a small surform file.

STEP 7

When smooth, draw a pencil design (whale or eagle head, etc.) on one side of the paddle blade, paint it, let it dry and oil entire surface of paddle with Watco oil or varnish surface.

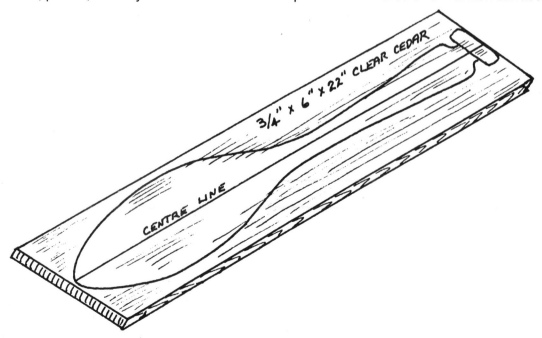

CARVED CEREMONIAL PADDLE

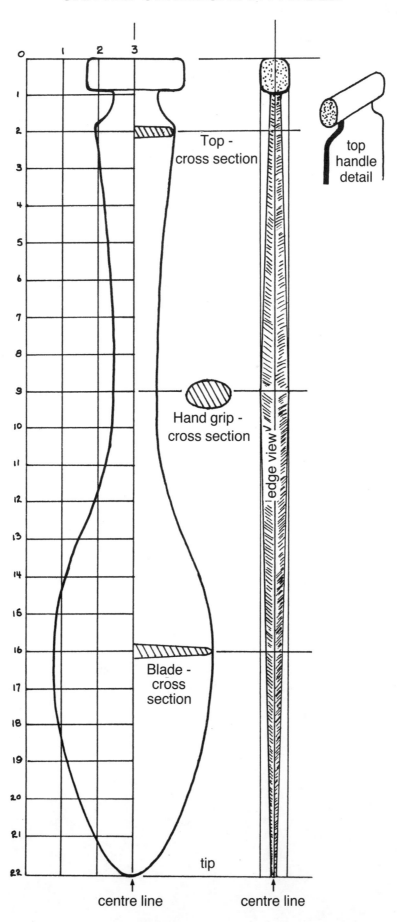

Top - cross section

Hand grip - cross section

Blade - cross section

edge view

top handle detail

tip

centre line

centre line

135

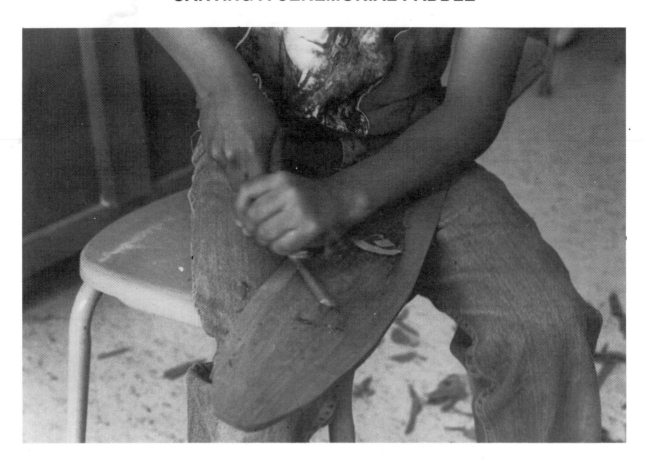

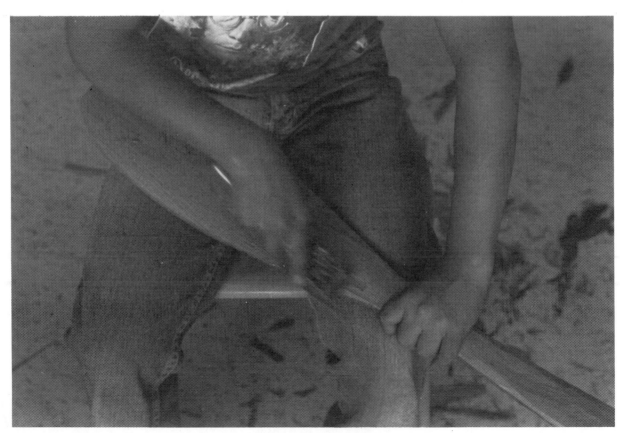

USING A RASP AND FILE

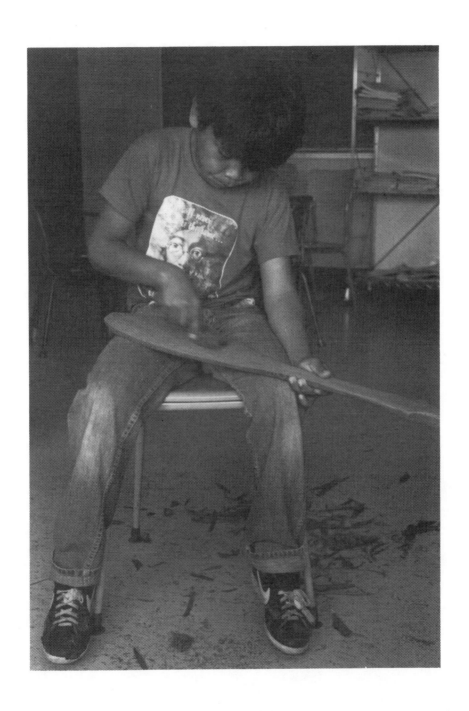

PAINTING A CEREMONIAL PADDLE

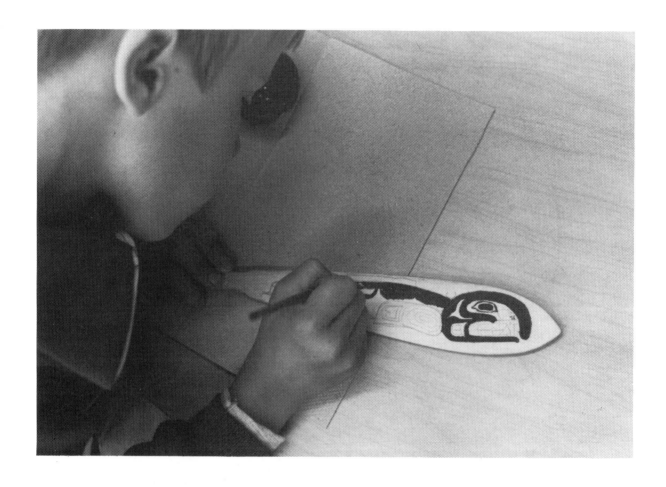

PAINTING A CEREMONIAL PADDLE

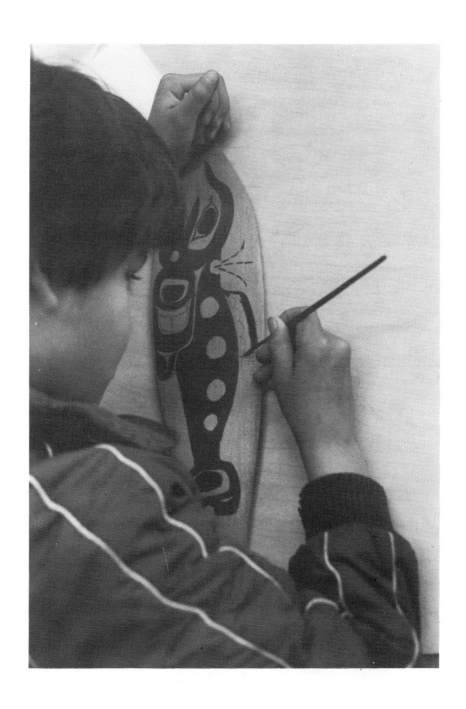

CEREMONIAL PADDLE

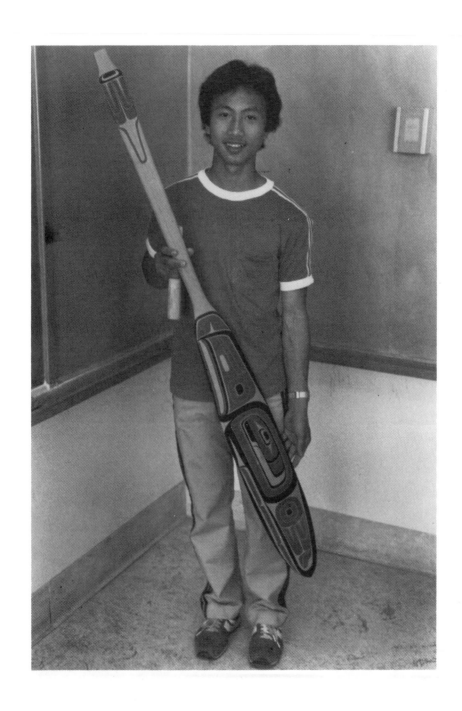

CHAPTER FIVE

IMPLEMENTATION

CHAPTER FIVE
IMPLEMENTATION

When implementing this curriculum, several decisions need to be made.

1. Will it serve only one class or grade?
2. Which grade or grades will be served?
3. How will the art program fit into the class' or school's timetable?
4. Will it be part of the Social Studies or Native Studies program? A part of the art program or simply a unit of study?
5. How often and for what length of time (minutes, months) will the program be operating?
6. Should all children be in the program or would some children benefit socially, physically, emotionally, cognitively, more than others?
7. Is the teacher willing to learn the concepts as he/she teaches and use Native resource people?
8. Does the teacher agree with the goals, objectives and evaluations set out with the program?
9. Will there be a long-term commitment to the curriculum (3-5 years)?
10. Will administrators support the program with funds, scheduled time, and their approval?
11. Will work be adequately displayed? (exposure to administrators, parents, and community)

Costs

Costs will vary according to the decisions made previously. Costs would include:

1. Materials and supplies.
2. Program teacher and/or aide.
3. Resource personnel.
4. Resource books and magazines.
5. Field trip transportation.
6. Entrance fees to galleries or museums.

Possible Uses

1. Elementary social studies unit.
2. Art unit.
3. Native Indian Art Studies.
4. Native Studies unit.
5. Reference book for teachers or artists.
6. Learners with motivational or special learning problems.
7. Band schools.
8. Senior citizens' activity centres.
9. Art schools.
10. Museums and universities.
11. Community night-school courses.

Inservice or Other Preparatory Activities

Options:
1. Workshops with interested teacher and/or staff.
2. Pre-reading and attempting the concepts alone.
3. Pre-reading and using Native resource people to assist in learning the concepts.
4. Familiarization with both the concepts and forms of gathering and recording data, alone or with resource personnel.
5. Run a pilot class with hand-picked students.
6. Run pilot classes with different types and ages of clients — evaluate.

HINT PAGE

1. Rules - black formline, continuous line no breaks
 - red does not touch black over an extended area

2. Do not let students trace unless that has been the assignment.

3. Any diagonal shaded areas are red.

4. Form "flow" line or "concept definition line" allow the major parts of the body to be joined together. It is like a white 'T' or crescent shape that relieves the solid black of the two joined formlines. It is the negative ground space that is left by the joining of the formlines; eg. head to body (throat), wing to body, tail to body.

5. Relieving shapes - 'S', Circle, 'T', Crescent and Ovoid.

6. T.S. means Teacher's Sheet.

7. S.S. means Student's Sheet.

Please make your own notes here. If you have time, please contact the authors re: hints and changes. We appreciate the opportunity to improve this curriculum.

MATERIALS

2 DIMENSIONAL DRAWINGS OR PAINTING ON PAPER, CARDBOARD OR WOOD.

Drawing paper 8" x 11" (see-through hard surface)

Folder for each student to put graphics and worksheets

Paint - Liquid Tempera (for paper or cardboard)
 - Acrylic or Latex (for wood)

Basic Colours - black, red, brown, green, yellow, white

Watco-type Clear Oil

Brushes - a variety of sizes #2 to #6
 - water colour type (soft hair-pointed)

Paint thinner or remover

Paper towels

Screw top, small size baby food jars or facsimile for paint

Tubes of paint - paint sparingly doled out by art teacher on paper towels

Hangers for wood

Paper cutter

Rubber cement

Coloured paper - for mounting graphics

Coloured chalk

Clear Red Cedar Panels (no knots)
 — 1" x 8", 1" x 10" or 1" x 12" (square cut)
 — 10" x 12", 14" lengths

Cedar veneer plywood ⅛"

Sand paper (80, 100 & 120 grit)

Sanding block - 3" x 1" x 5"

Miscellaneous - Pencils, H.B.
 - Ruler
 - Circle Templates (12 to a class)
 - Eraser

Display boards

MATERIALS

CARVING
(BAS-RELIEF WOOD PLAQUES AND SIMPLE 3 DIMENSIONAL CARVINGS)

Clear edged grain red cedar panels
(Dressed S4S 7" x 8" - 10" - 12" squared to 12" to 14" lengths)

Selection of sand paper
(80, 100 and 120 grit)

Set of knives (3) - straight knife (1)
- slight curved knife (1)
- full curved knife (1)
(1 set shared between 2 pupils)

Workmate type of clamp bench (2 per class)

Small sur-form file (1 for every 4 pupils)

Acrylic or latex paint in basic colours - black, red, brown, green, yellow, white

Wall hangers for wood plaques

Brushes - a variety of sizes #2 to #6
- water colour type (soft hair-pointed)

Oil, etc. - (necessary for painting) (see 2 dimensional drawings' materials)

5 minute epoxy glue

Sharpening stone and oil

Drill and bits

Broom and dustpan

Band-aids

Carving aprons

CONCEPT #1
BASIC OVOID

CONCEPT #2
OVOID WITH EYELID LINE

CONCEPT #3
'U' SHAPE

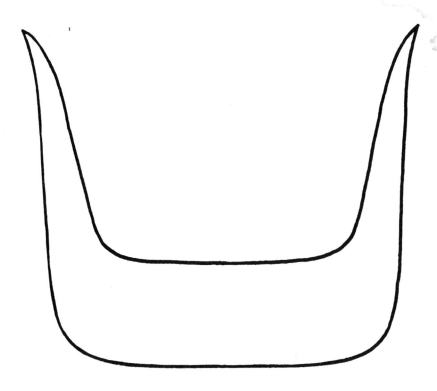

CONCEPT #4
SPLIT 'U'

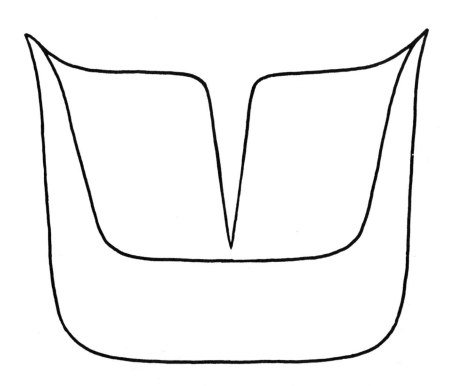

CONCEPT #5
REVERSE SPLIT 'U'

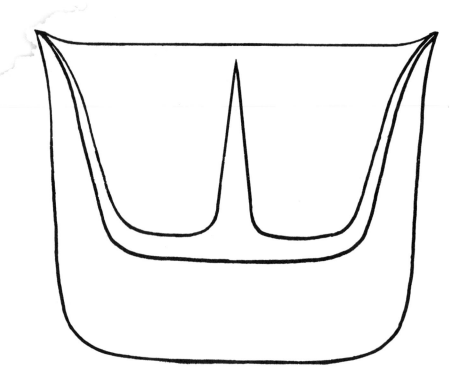

CONCEPT #6
VARIATIONS IN 'U' SHAPES

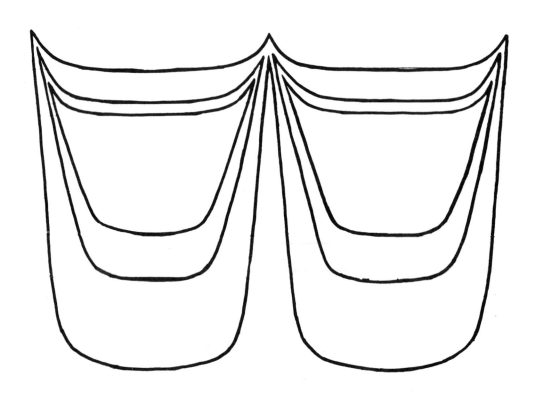

CONCEPT #6
VARIATIONS IN 'U' SHAPES

CONCEPT #7
'S' SHAPE BOX END DESIGN

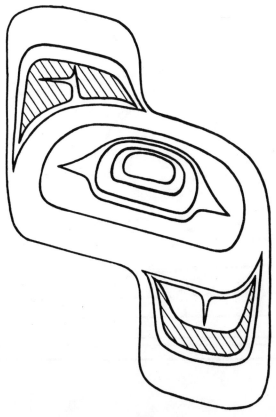

CONCEPT #8
SALMON-TROUT HEAD

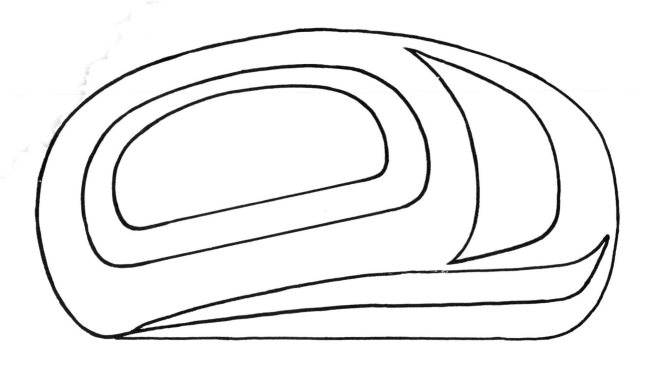

CONCEPT #9
KILLER WHALE HEAD

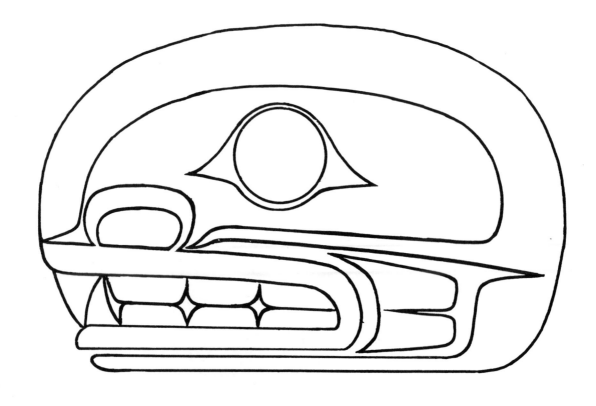

CONCEPT #10
EAGLE HEAD

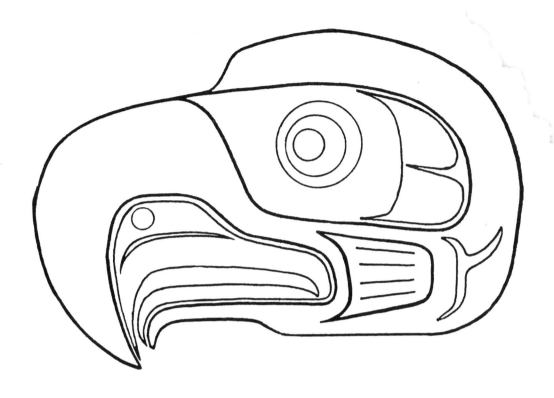

BEAR HEAD

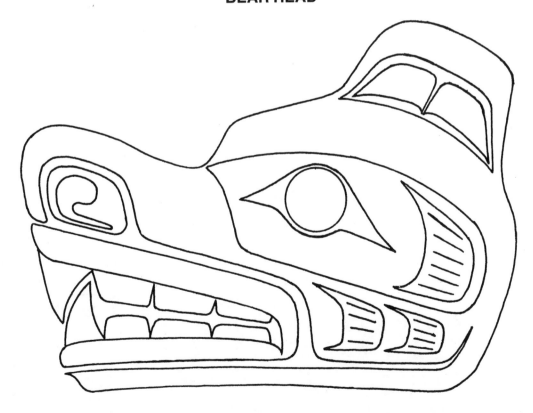

THUNDERBIRD HEAD

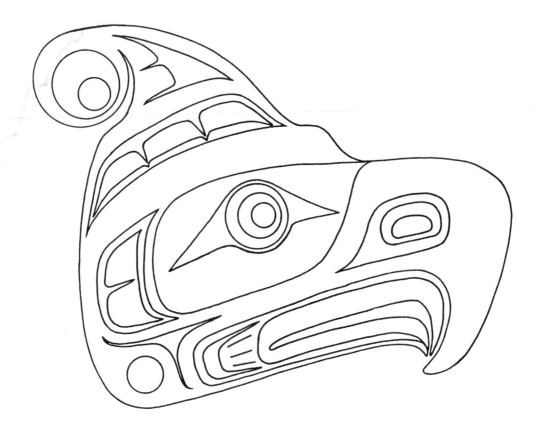

SALMON HEAD

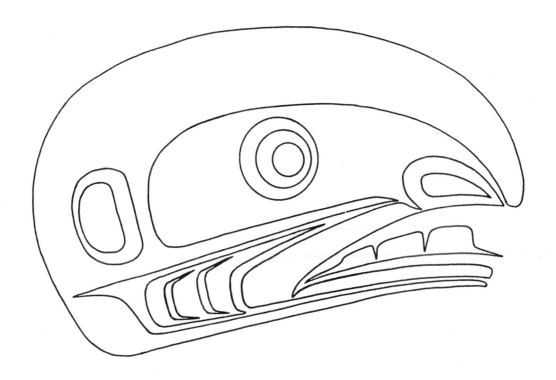

WOLF HEAD

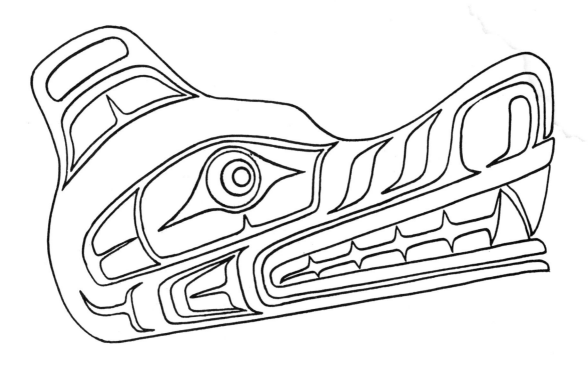

KILLER WHALE HEAD

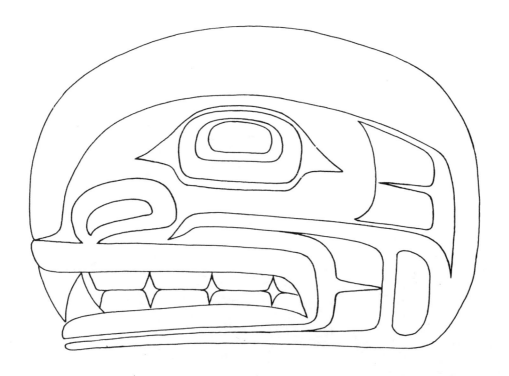

BEAVER HEAD

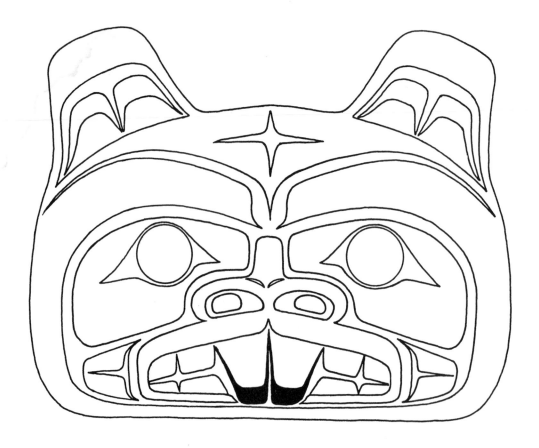

RAVEN HEAD

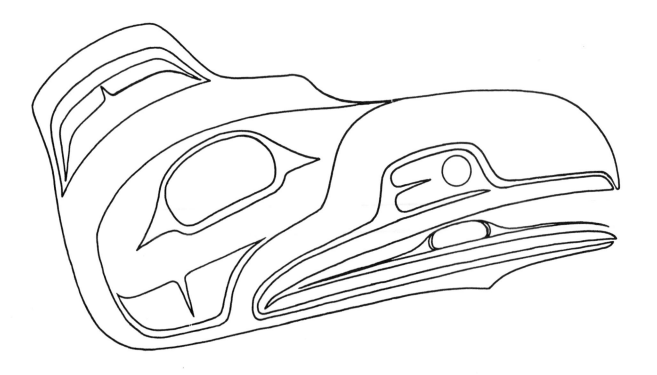

KILLER WHALE

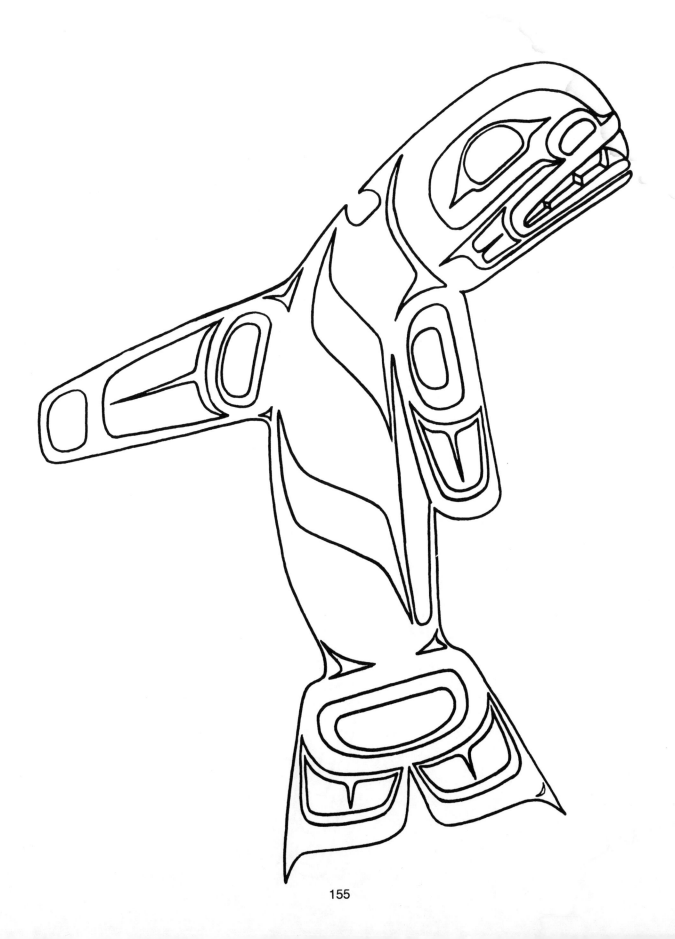

KILLER WHALE

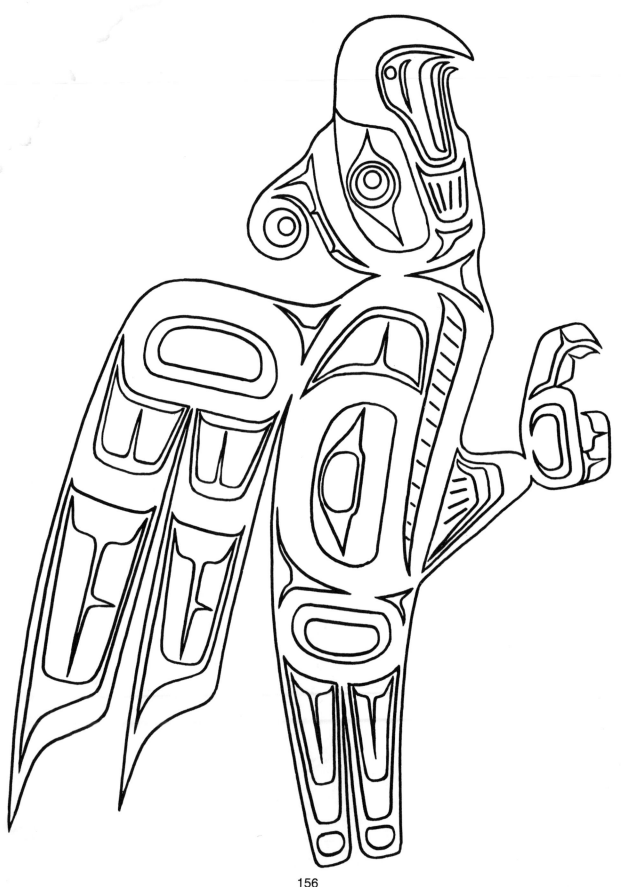

WOLF

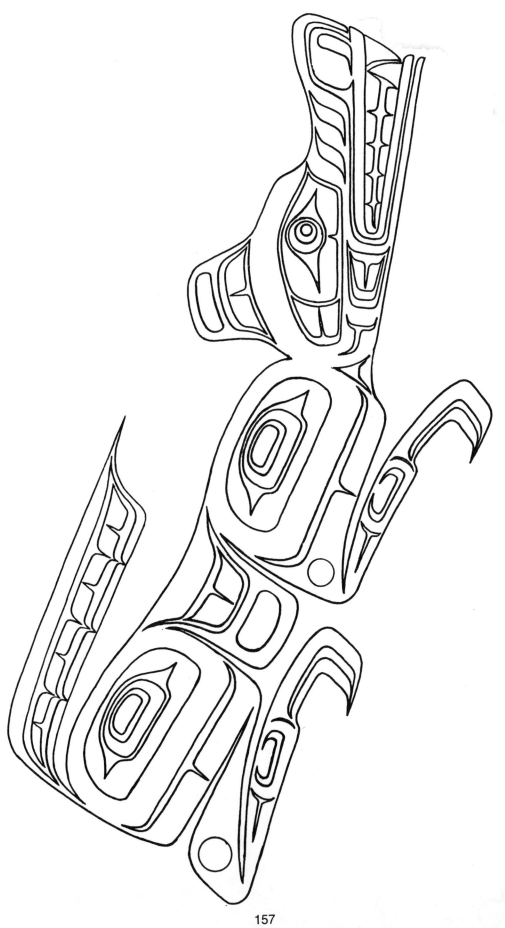

BIBLIOGRAPHY